The HIP HOP COOKBOOK

Four Elements Cooking
by Cutmaster GB

For Barbara

Contents

Introduction

Since I first picked up a spray paint can in 1979, Hip Hop has played a decisive role in my life. Luckily, I never had to live from Hip Hop but instead have been able to live *for* Hip Hop. Over the past couple of decades, I've had the privilege of working with great artists to contribute to the global Hip Hop scene and in particular to help establish the scene here in Germany. This has given me the opportunity to meet and become friends with artists from all over the world. New York City, the birthplace of Hip Hop, was also the place where the idea for the Hip Hop cookbook came about.

Though I'd been to New York many times in the past, I was really excited about my trip in the spring of 1998, because it would my first trip there with my daughter

Gillian, who was only a few months old at the time. Not only would that be her first flight to the States, it would also be her introduction to New York City and some of the Hip Hop scene's greatest artists.

The first item on our agenda was to visit Popmaster Fabel from the Rock Steady Crew (RSC). Fabel and I originally met at the beginning of the 80s at an open-air jam while shooting the documentary 'Breakout: Tanz aus dem Ghetto' (Breakout: Dance out of the ghetto).

'Breakout' was a German television production by Fatima Ingramhan, who also grew up in Frankfurt and went to the same elementary school as me.

During our visit, Fabel and his wife Christie invited us over for a truly phenomenal dinner. It was at this dinner that the idea for this book first came into being. As I started to think about the idea of making a book, I realized I've had a lot of fun experiences and adventures related to food. I also realized that there are a lot of other people in the Hip Hop world who share my passion for good food. One of my best friends, Katmando from Munich, went from being an artist to a professional chef. He and I cook together almost every time we get a chance to meet and talk about this book, Hip Hop and dishes from around the world.

Some of my fun and silly experiences relating to food which inspired me were:

• The never ending search for sesame noodles with Fabel, Mr. Wiggles and Crazy Legs all over Frankfurt, which in the end lead us to my favorite Chinese restaurants. The owners were glad when we finally left, and afterwards we figured out that sesame noodles weren't very well known in Frankfurt.

- DXT's pizza, which he requested to be very spicy, only to spit it out after taking one bite and dumping it in the nearest trash can. For the next few days, he was McDonald's best customer while Katmando, Futura 2000 and I had fun eating sushi and steaks.

- The food fight at the Novotel where we had only booked eight rooms at the 1994 Spring Jam, but 50–60 homeboys and flygirls ended up showing up for breakfast. Someone started throwing food and at the end of breakfast the place was trashed.

- While dining in the Village in NYC with Katmando and RickSki (LSD) I ended up being covered in the contents of an entire bottle of ketchup which was suddenly emptied all over me and the mirror behind me. The sight of me covered with ketchup had the packed restaurant laughing loudly.

- EMI invited my group Bionic Force to a four-star restaurant, and one of us (who shall remain nameless) ordered his steak "well done," which resulted in an intense ten minute discussion with the waiter but never resulted in him getting a steak.

- In 1992 on the Godfathers of Rap Tour, we were not allowed to have food from catering because we were the opening act. Luckily, Kurtis Blow stuck up for us and from that night on we had full stomachs every night. It was on this tour that I had one of my best concerts in Hamburg at the Große Freiheit. Unfortunately though, no one ever announced that the opening act was German (except for our MC).

Thanks to my good friends and great artists in the Hip Hop community, there are many more stories I could share…

A lot of new ideas are met with skepticism. In 1995 I produced my record 'Dedication.' Since I did not want to release it on my own label, Earth Edge Recordz, I asked Akim whether MZEE Records was interested, but he told me that b-boy music would not sell. Years later, Akim completely changed his mind and today MZEE Records is well known for its b-boy tracks. After this, 'Dedication' was finally released on the 'Battle of the Year' compilation at MZEE and on my own label.

In 2008 at our annual Christmas dinner, our place was full of good friends, including Can Two, the Rick Brothers, Bomber and lots of great people and artists. It was there that Akim and I were talking about my idea for this cookbook. After a bit of discussion, I decided to announce my idea to make a Hip Hop cookbook to everyone. Much like Akim's initial reaction to my suggestion that MZEE Records release b-boy music, my friends looked at me with disbelief and doubt at my cookbook idea. Having faced skepticism about new ideas before, I knew it would be hard to win people over to my point of view, but what is it that connects the world? Hip Hop and food! Both require creativity, which is what makes the artists in this collection stand out. Without exception, the artists in this book are pioneers of Hip Hop in their respective countries and most of them are friends I have known for decades. Not all of us are chefs, so I was really surprised by how amazing these dishes were when I tried the recipes out myself. I love good food!

In the end I owe my greatest thanks to my wife Barbara! She has been a part of my unconventional Hip Hop lifestyle since 1992. She has done everything from organizing the 1994 Spring Jam with Bomber and myself, to supporting me with her creativity and advice throughout this unusual project. Love ya!

And to everyone else out there who is passionate about Hip Hop and food, enjoy reading and trying out these recipes!

One Love, Cutmaster GB

Banana Nut Bread

Jorge "FABEL" Pabon was born and raised in Spanish Harlem, NYC. He is President of the Hierophysics crew and Senior Vice President of the Rock Steady Crew, and was also active in Magnificent Force and the Electric Boogaloos. Fabel is also co-founder of GhettOriginal Productions, Inc. With GhettOriginal, Fabel co-authored, co-directed, and co-choreographed the first two Hip Hop musicals ever. Fabel currently teaches dance classes and is working on three documentaries.

Christie Z Pabon is Fabel's wife. She puts out the 'Tools of War Grassroots Hip Hop Newsletter' with Fabel and is CEO of DMC USA. Since 2003 she has organized the True School NYC Summer Park Jams in the Bronx and Harlem.

This recipe was handed down to Christie Z Pabon by her aunt, Gail Kandor. May she rest in peace.

From Christie Z Pabon: Tools of War Grassroots Hip Hop & DMC USA

Ingredients:

- 75g *(⅓ cup)* **vegetable shortening**
- 170g *(¾ cup)* **light brown sugar**
- 3 ripe or overly ripe **bananas**
- 2 **eggs**
- 160g *(1½ cups)* **flour**
- 1 tsp **salt**
- 1 tsp **baking soda**
- 120ml *(½ cup)* of **whole milk**
- 60g *(½ cup)* of **chopped nuts (walnuts or almonds)**

- Cream together the vegetable shortening and sugar. Add the bananas and eggs.
- Sift flour with salt and baking soda, adding it to the creamed mixture and alternating with milk.
- Stir in chopped nuts.
- Bake in a greased loaf pan at 180° C *(350° F)* for one hour.
- Remove loaf from the pan and place on a rack to cool. Once cool, wrap in aluminum foil to preserve freshness.

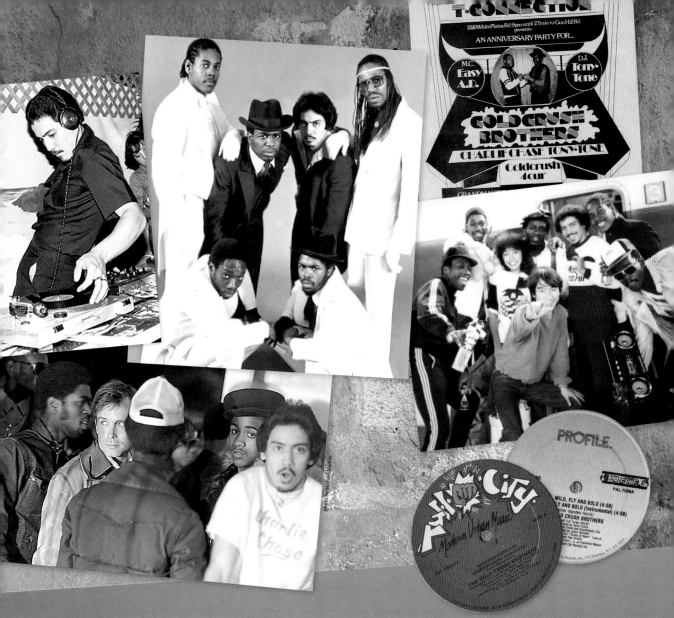

Charlie Chase

Born in New York City, Charlie Chase was raised in Williamsburg, Brooklyn, until the age of twelve. Then he moved to the Bronx, where he became a musician and true Hip Hop pioneer during the early years of the movement in 1975. Charlie Chase was the first Latino DJ to officially emerge and establish Latinos as a force in Hip Hop.

Despite a lot of negative criticism in the beginning from African Americans and Hispanics for being a Puerto Rican DJ playing Hip Hop music, Chase played in the streets, parks, clubs and schools of New York City with other pioneers such as Kool Herc, Afrika Bambaataa, Grand Wizard Theodore, Grandmaster Flash and many others. He became a force to be reckoned with, entertaining the masses and representing Latinos everywhere by playing Hip Hop, salsa, R&B, house, disco and rock. Playing everything was how he gained respect as a DJ and stayed focused on his music.

Chase co-founded the world famous Cold Crush Brothers with his partner Tony Tone. Together they recruited Grandmaster Caz, Hut Maker JDL, Almighty KG and Easy AD, becoming and continuing to be one of the primary influences emulated by many DJs, MCs and rappers in Hip Hop. In 1981 Chase got his first movie role, playing himself in the first Hip Hop movie ever made. In the cult hit 'Wild Style' Chase had a small speaking part and performed with his group the Cold Crush Brothers. His role in this movie was the break he needed to take his talent all over the world, rocking Japan, Germany, Italy, England, Switzerland and many other countries—playing in some of the most famous clubs and arenas like The Roxy, Studio 54, Roseland, Madison Square Garden and more.

In 2003 Chase was inducted into the Technics, DMC DJ Hall Of Fame, joining the ranks of Afrika Bambaataa, Jazzy Jay, Jazzy Jeff, Grand Wizard Theodore, Grand Mixer DXT, Jam Master Jay, Grandmaster Flash, Red Alert, DJ Premier, Mixmaster Ice, Grandmaster Caz and more. Today, Chase continues to play for his fans all over the world and has become a true Hip Hop DJ icon.

*You can't be hungry for God if you're
filled with the junk food of the world.*

Roasted Pork
(Arroz con Habichuelas y pernil)

Ingredients:

- **2kg** *(5 lbs)* **boneless pork shoulder**
- **½ Tbsp garlic powder**
- **½ Tbsp oregano**
- **½ Tbsp adobo (see recipe on page 110)**
- **olive oil**
- **vinegar**

- Make a paste by mixing the garlic, oregano, and adobo. Slowly add an equal amount of olive oil and vinegar until it becomes a very thick paste.
- Make cuts about 5 cm *(¼ in)* deep into the pork skin.
- Rub the entire roast with the paste, making sure the entire shoulder and all holes are completely covered.
- Place the pork in a roasting pan and cover it with aluminum foil.
- Cook the pork in a preheated oven at 190° C *(375° F)* for about 3 hours. Periodically check the pork with a knife or fork. When the right tenderness is achieved it is ready to serve.

The roasted pork is best served with yellow rice and red beans (see recipes on page 110 and 111).

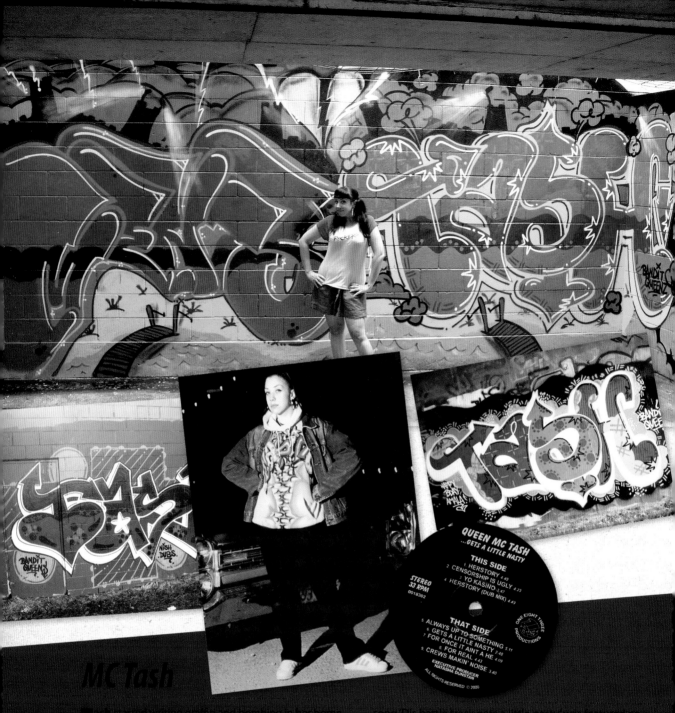

QUEEN MC TASH
...GETS A LITTLE NASTY

THIS SIDE
1. HERSTORY 4.40
2. CENSORSHIP IS UGLY 4.23
3. YO KASINO 2.47
4. HERSTORY (DUB MIX) 4.49

STEREO
33 RPM
0018302

THAT SIDE
5. ALWAYS UP TO SOMETHING 5.11
6. GETS A LITTLE NASTY 2.48
7. FOR ONCE IT AINT A HE...
8. FOR REAL 4.09
9. CREWS MAKIN' NOISE 3.40

ONE EIGHT THREE PRODUCTIONS

EXECUTIVE PRODUCER
NATASHA DUNSTAN
ALL RIGHTS RESERVED © 2000

MC Tash

Tash started writing graffiti and bombing in her home-
town of Adelaide in 1991—doing her first piece in
1993. Shortly thereafter, she did her first Hip Hop radio
show 'Crack One Two' on Radio 5UV in Adelaide. This show
allowed her to meet local MCs and DJs who inspired her
to start rapping and DJing at shows, on the radio and on
demos in Melbourne. Tash went on to produce and host
her own bimonthly Hip Hop TV show 'Loungin' on the
community TV station ACE TV. At the tender age of 12, she
held her first memorable interview with the Beastie Boys.

In 1996 she moved to Melbourne, where she hosted
the national music television show 'Recovery' on ABC.
Unfortunately, she had to give up the show a year later
after the Prime Minister of Australia banned her from
television for advocating illegal graffiti on air. In 1999 her

song 'Dis battle track gets a little nasty' was featured on
the Australian Hip Hop compilation 'The Four Element
Effect'. The same year, she was the presenter of a national
children's show and became manager and co-owner of
the Butter Beats record store.

Then, in 2000 she was a guest artist at a jam in Auck-
land, New Zealand, and wrote and co-produced her debut
Hip Hop album, '...Gets a little nasty'. Her work has also
been featured in many exhibitions and she curated the
exhibit 'Wordy Rappinghood' in Brisbane. In 2002 she took
her first painting trip to New York, and began to get more
active internationally—including performances in Central
Europe, Scandinavia, Singapore and elsewhere. She was
also featured in the books 'A-Z of Australian Graffiti' and
'World Graffiti'.

Tash's Veggie Lasagna
with ricotta cheese

Ingredients:

- olive oil
- balsamic vinegar
- salt and pepper to taste
- dried oregano
- 1 bunch of torn, fresh basil
- 1 chili, finely chopped
- 4 cloves of garlic, crushed
- 1 brown onion, finely chopped
- 1 red or green bell pepper, finely chopped
- 1 head of broccoli florets, separated
- 1 carrot, finely chopped
- 6 mushrooms, finely chopped
- 1 zucchini, finely chopped
- 4 cups of baby spinach leaves
- 500g *(18 oz)* of grated mozzarella cheese
- 120g *(1 cup)* of grated parmesan
- 1 large tub of light ricotta cheese
- 2 packets of lasagna noodles
- 3 cans of chopped tomatoes
- 1 large jar of tomato-based pasta sauce

- Sauté the garlic, onion and chili in olive oil in a pot until the onions become translucent.
- Add the rest of the veggies (except the spinach!) and a big-ass splash of balsamic vinegar, and stir for 2 minutes.
- Pour in the tomatoes and pasta sauce and gently simmer for 20 minutes.

- Season to taste with salt and pepper, oregano and chopped basil.
 Note: You must put in loads of basil and pepper to get the mad flava!
- Pour some sauce into a large baking tray/dish (just enough to cover the bottom).
- Layer with lasagna sheets, more sauce, spinach leaves and then mozzarella.
- Repeat the layering 4–5 times.
- Cover the last layer with sauce, then spoon ricotta over the whole lasagna.
- Then, top the lasagna with more mozzarella and finish with grated parmesan cheese.
 Note: Parmesan doesn't melt, so I always finish off baked dishes with parmesan to brown the cheese and get a golden effect. It works just as well on pizzas, macaroni and cheese, etc.
- Bake in a preheated oven at 200° C *(390° F)* for 30–40 minutes.
- Remove from the oven when golden brown and let stand for 10–15 minutes.

Serve with an ice-cold beer, a side of green salad and garlic bread … YUM!

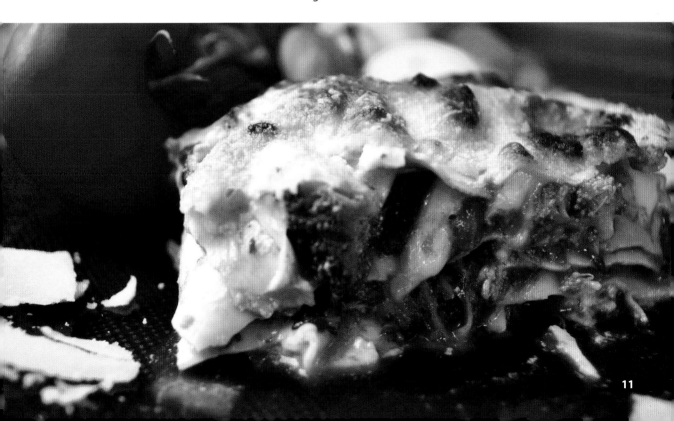

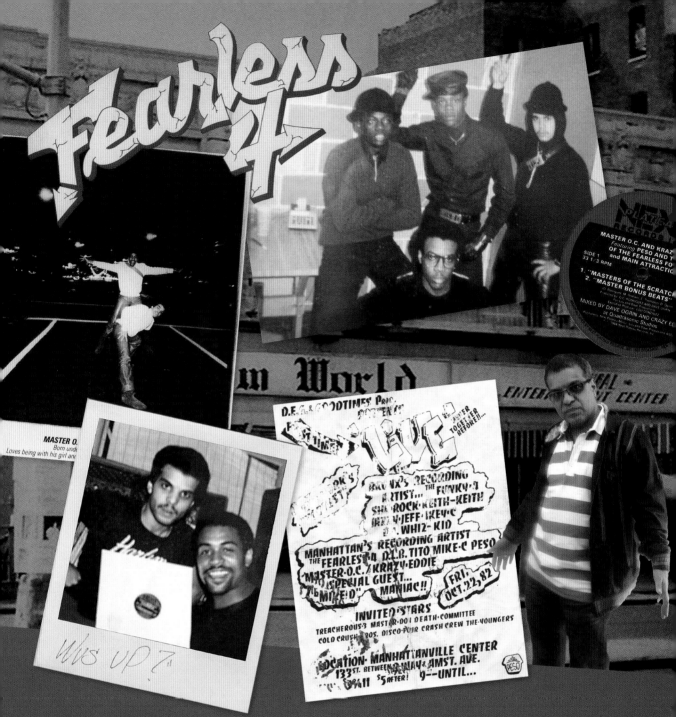

Master OC
The Fearless Four

The **Fearless Four** from Harlem, New York, was the first rap group to be signed to a major label. Founded by Devastating Tito and Master OC, the group was originally a duo known as the Houserockers Crew, but they began to pick up new members; Mike Ski, Troy B (formerly of the Disco Four), and the Great Peso were among the first. Troy B was replaced by DLB, and the lineup was later completed by Mighty Mike C and Krazy Eddie. The Fearless

Four released their debut single on the Enjoy label in 1981—'It's Magic'. The follow-up 'Rockin' It' became a cult electro classic, with its Afrika Bambaataa-inspired sampling of Kraftwerk's 'Die Mensch Machine'. 'Rockin' It' helped to get a deal with Elektra, for whom Fearless Four debuted with 'Just Rock'. The Kurtis Blow produced follow-up, 'Problems of the World Today' (1983), became the group's second most successful single. Master OC and Krazy Eddie recorded a few singles together from 1984 to 1985, including 'Masters of the Scratch.'

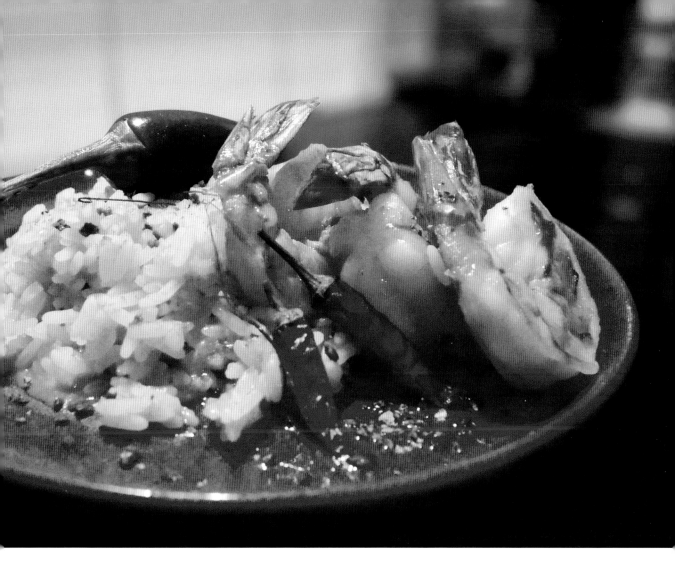

Spanish Rice with Shrimp

Ingredients:

- ½ can of tomato sauce
- 2 Tbsp recaito (see recipe on page 110)
- 1 portion sazón (see recipe on page 111)
- 1 Tbsp adobo (see recipe on page 110)
- 16 jumbo shrimp
- 400g *(2 cups)* of rice

- Add the tomato sauce, recaito, sazón and adobo to a pot and bring to a boil.
- Add the shrimp and 2 cups of water to the pot and bring it to a boil again.
- Add the rice and stir for 1 minute at a boil, then reduce the heat to simmer, cover and cook for 30 minutes.

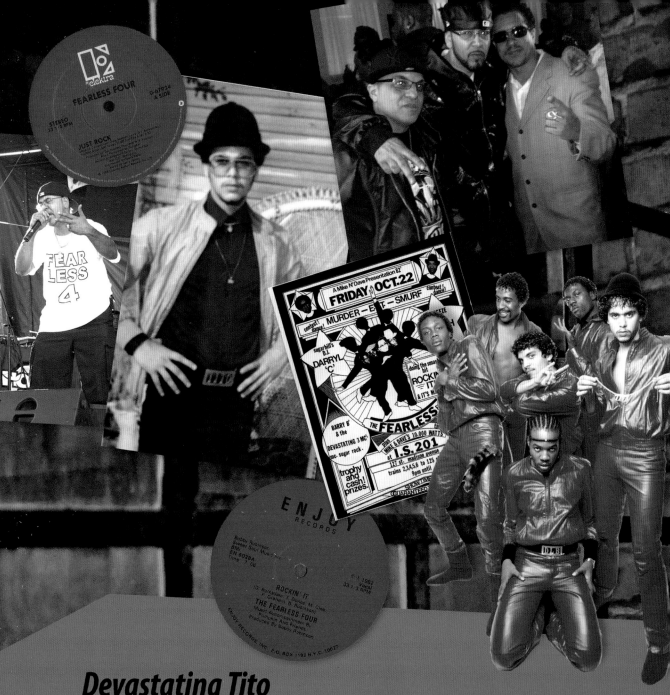

Devastating Tito
The Fearless Four

Tito, aka Devastating Tito, was born In the 1960s in Puerto Rico. When Tito was only one year old, he and his family moved to Harlem, New York City, where he was raised in the Grant Projects. It was there that he made a name for himself as a founding member of old school Hip Hop, while laying the groundwork for the new age of Hip Hop currently dominating the airwaves.

In 1981, after collaborating with different artists, Tito became well known as one of the Fearless Four's elite members and one of the most prestigious Hispanic Hip Hop artists. Tito and his group contributed a number of hits to the Hip Hop vault, such as 'Rockin It,' 'It's Magic,' 'Dedication,' 'This is For Our Fans,' 'Just Rock' and 'Problems of the World Today.'

Later, in 1993, Tito was signed by Columbia Records. Tito was the mastermind behind the three-man squadron Menagerie. Tito has blessed stages from the state of New York all the way to Amsterdam.

After all these years, the Devastating Tito has been labeled one of Hip Hop's legends. He is now going forth by honoring his peers in his new 'Hip Hop Legend' series.

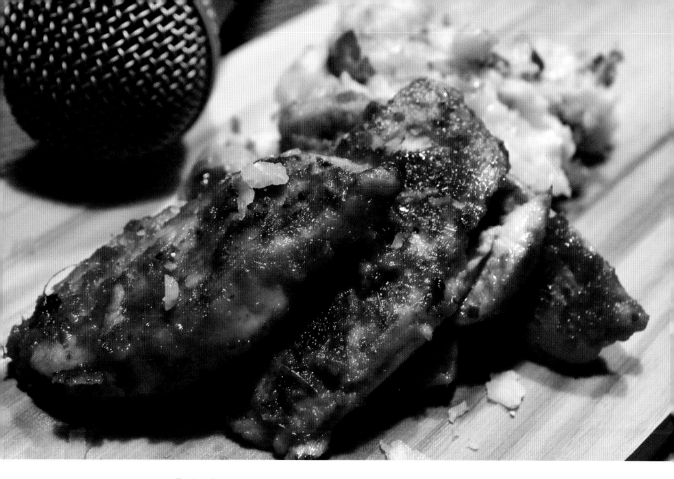

Chicken Breast in Honey Ginger Sauce
served with garlic mashed potatoes & steamed broccoli

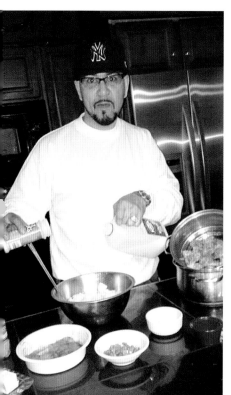

Ingredients:

Note: All ingredients without amounts are to taste / hunger.

- boneless chicken breast
- 1¼ tsp sazón (see page 111 for recipe)
- cumin
- 1 onion
- garlic powder
- turmeric
- 115g *(½ cup)* ginger
- 120ml *(½ cup)* honey
- olive oil
- red potatoes
- butter
- shredded cheese
- broccoli
- minced garlic

Chicken
Wash and take the skin off. Season with sazón, cumin, onion and garlic powder. Shred the ginger into a bowl, add the honey and stir. Marinate the seasoned chicken in the honey and ginger. Heat a sauté pan with a little olive oil. Place chicken breast in the pan on low heat and cover with a lid. Cook for 30 minutes, turning halfway through, then remove the lid and let the chicken brown.

Mashed potatoes
Peel and cut red potatoes. Add salt and garlic powder to water in a large pot and boil the potatoes until soft. Strain and mash potatoes. Add butter and garlic powder to taste. Whip to desired texture. Top with shredded cheese.

Broccoli
Wash and cut broccoli spears and place them in a steamer. Sprinkle turmeric, sazón and minced garlic on the broccoli and let steam until tender.

Enjoy!

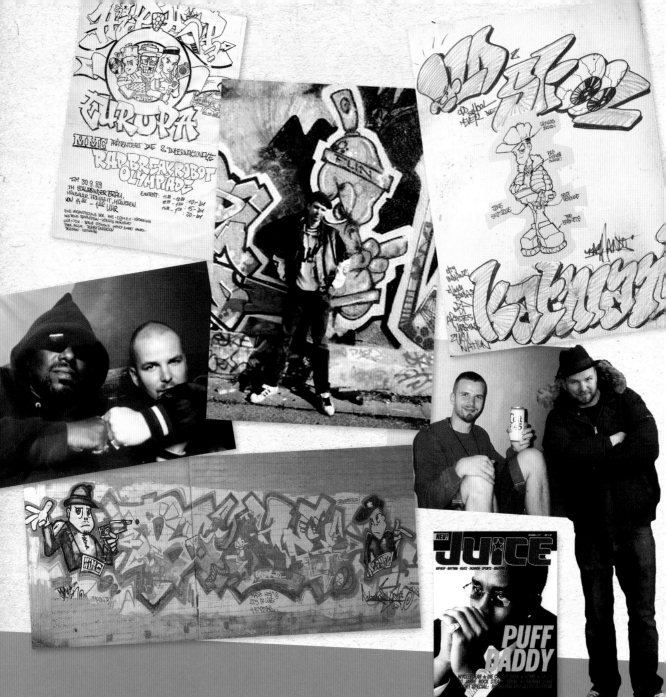

Katmando

Katmando was born on April 29th, 1968 in Munich. He is one of Munich's early writers. In the early 80s he painted with Loomit, Cowboy, Blash and Anubis (the Force). He is a member of the graffiti writer crews PMC, GSG9, GBF and FKC. In addition, he was one of the early members of the Universal Zulu Nation in Germany. In 1986 Katmando became a founding member of the Euro Graffiti Union.

Alongside his activity as a graffiti artist, he was also the organizer of some of the first German Hip Hop jams, for example the 'Hip Hop Olympiade' in Munich. He was also an active b-boy, and has performed in videos such as Afrob's 'Ridin' on Chrome'. In 1991 he produced the 'Krauts with At-

titude' with Michael Reinboth. In 1997 he founded what is today the biggest European Hip Hop magazine, 'Juice.'

In addition, he works as a consultant for Edding, BMG Ariola, Adidas (also as a freelance designer) and Cazal. He released the 'Battle of the Year' soundtracks on his label Masters of Broadway Records from 2000 to 2002. He received a gold disc for Jay Z's 'Hard Knock Life.' He has also participated in numerous solo exhibits, including at the Bambi Prize ceremony in Offenburg, the La Eitta Invisibile in 1993 in Terni, Italy, the Return of the Soft Letter in 2002, and Requim Pour Uncon in 2005, just to name a few.

Since the end of the 90s he has been active as a DJ and he has worked as a professional chef on a freelance basis since 2004.

Lobster in Beer
with cornbread muffins—Soul Food

Of course this can also be made with prawns, but my friends and I prepared it with lobster—and then ate it!

Lobster:

- 1 lobster (live)
- vegetables: celeriac, onion, carrot
- 1 bottle pale lager beer (such as Augustiner pale lager)
- 3 cloves of garlic, chopped
- equal amount of chopped ginger, pepper sauce (e.g. Tabasco), honey and fresh cilantro

- Place the lobster in a pot of boiling water with the vegetables. Cook for 10 minutes.
- Remove the pincers and tail, peel the body. Keep the shell and head!
- Sauté the shell and head in hot oil, add the beer, garlic, ginger, pepper sauce and honey. Let simmer until the sauce thickens.
- Remove the shell and the head from the pan. Remove the pan from the burner and place the lobster meat in the sauce, allowing it to absorb the flavor. Garnish with cilantro when serving.

With prawns

Wash 1 kilo of prawns, remove the heads and the intestines. Sauté the heads, add the beer and follow the remaining steps as above. Very tasty!

Cornbread Muffins:

- 375g (17 oz) cornmeal
- 125g (4 oz) wheat flour
- 3 ½ tsp baking powder
- 150g (⅔ cup) sugar
- 2 tsp salt
- 4 eggs
- 225g (1 cup) butter
- 375ml (13 oz) of milk
- muffin tin (greased)

Mix all of the ingredients except the milk and butter. Melt the butter, let it cool and then mix it together with the milk into the batter. Bake at 220° C (428° F) until golden brown (approx. 15 minutes). Best served warm, with salted herb butter. Makes 10.

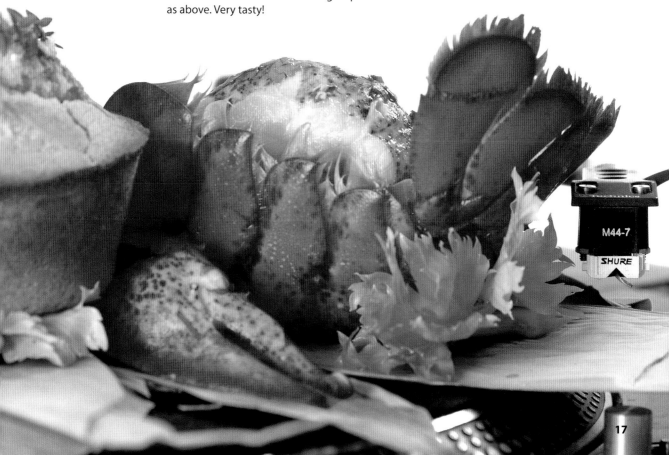

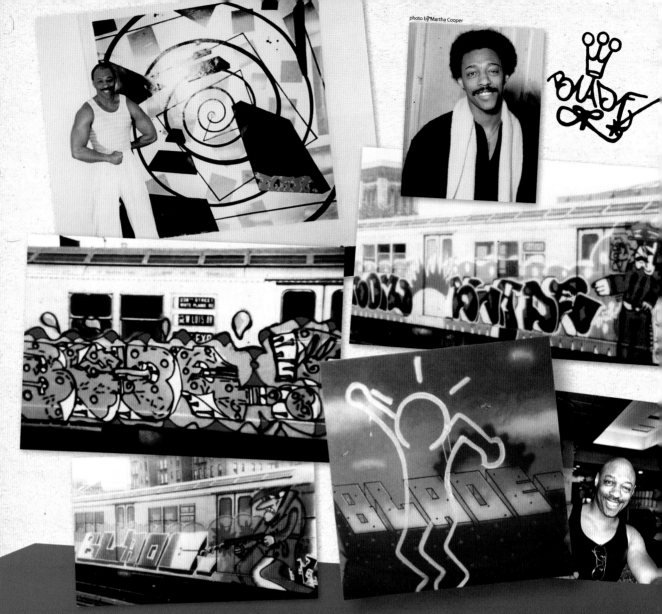

photo by Martha Cooper

Blade TC5

Blade is a member of one of graffiti's most famous crews, The Crazy Five.

In the early 70s, Blade and his boys Death, Vamm, Crachee, Tull, and his partner Comet bombed the trains with full force, often under the influence of various substances. Their style represents the freedom of youth, rock and roll, and teens without limits making their mark.

Blade's career on the trains can be compared only to a select few other masters. His spontaneity and never-ending output made it possible for him to bring his most bizarre ideas to life. His images were not political, but more personally focused. Blade's pieces directly reflected his real life, using the trains as his diary. Anything from his favorite shirt to a night out partying with his friends or bandmates could become Blade's subject matter. He blasted out ideas that were simple and cartoony, but with a serious psychological energy and unique impact.

Unlike many of his peers, Blade rarely copied characters from popular culture, preferring simply to create his own, which resided within his own fantastic world. Some of his best known classics are: the Joint Man, the Dancing Ladies, the Galaxy Gangster and the Easel Man. All of these characters eventually made each other's acquaintance when Blade brought them together for a masterpiece party on a whole car, creating a jovial gathering that exited Blade's dimension and entered into our own.

Usually working off-the-cuff, Blade never feared the unknown, and his pieces entered into a creative territory in which most others would lose their footing. His whole cars were massive productions, using a larger-than-life scale and superhuman sizes. In terms of the amount of paint stolen and quantity of pieces produced, Blade could hold his own against an entire crew of graffiti writers. His work is a testament to the indisputable power of raw energy, unfettered imagination and the triumph of substance over technique. Simply put, Blade is probably the most creative painter of ideas and situations in the history of writing.

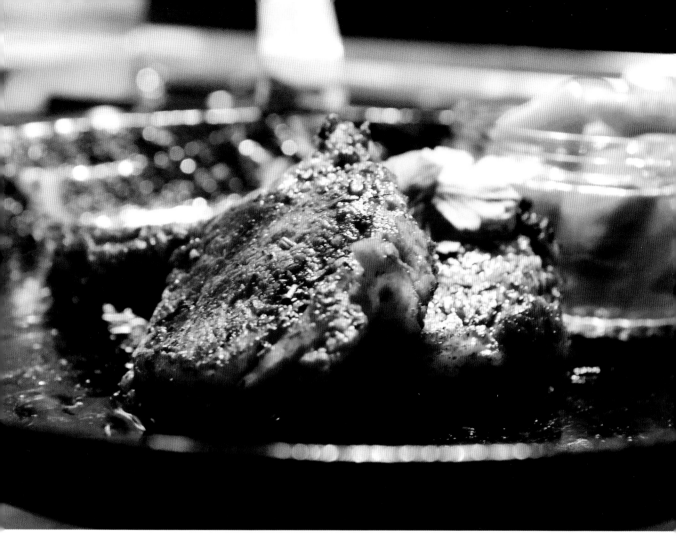

Blade's Australian Chops

Ingredients:

I usually don't measure the ingredients. I decide on the amount depending on the size of the chops.

- 15 lamb chops (use more or less depending on your number of guests)
- 355 ml *(1½ cups)* orange juice
- 2 Tbsp maple syrup
- 1 Tbsp mustard
- 1 big onion
- 2–3 garlic cloves
- 1 green bell pepper (seeded)
- oil
- black pepper to taste

- First, chop the onion, bell pepper and garlic.
- Brown both sides of the chops in a skillet with a little bit of oil.
- Add the chopped vegetables and black pepper.
- Mix together the orange juice, maple syrup and mustard. Stir and pour on top of the chops (use enough to cover the pork chops).
- Cover with a lid and let simmer on a low flame for 20 minutes (stirring occasionally).
- When the chops become tender and the mixture is absorbed, the meal is ready!

OH YEAH
BLADE'S READY TO CHOW DOWN.
AND A ICE COLD BEER TO
WASH IT DOWN.
YESSSSS!

BLADE
-N-
POTATA

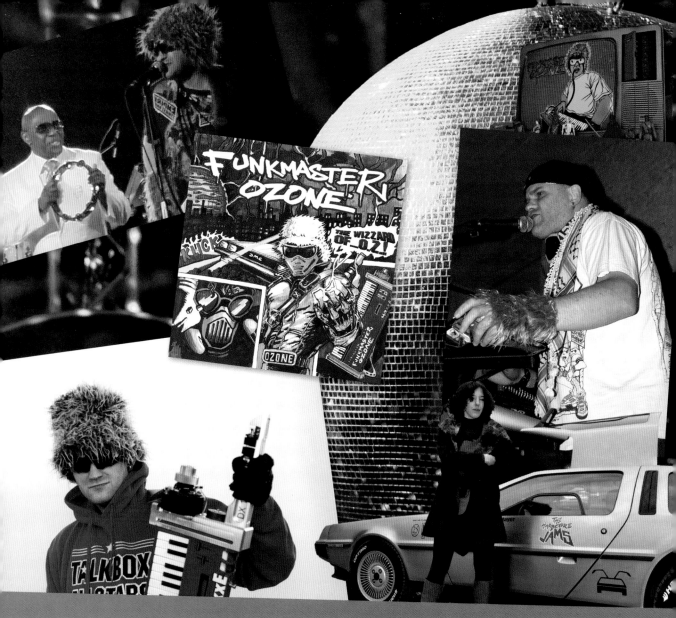

Funkmaster Ozone

Infected by the breakdance virus in 1983–84, Ozone became increasingly interested in Hip Hop music. After trying out breakdancing for himself, Ozone encountered the Electric Boogaloo. Then, in 1985, he saw a music video by Roger Troutman for the first time, which affirmed his passion for funk. Impressed by his talk box sound, Ozone bought some of the master's records along with other artists with the typical 80s sound. This style continues to shape his musical tastes today.

Always aware of his musical background as an Electric Boogie dancer and battle DJ, Funkmaster Ozone produces a wide spectrum of P-funk, eighties funk, old school electro tunes and drum machine-heavy old school Hip Hop beats. No matter what style he's using, Ozone's sound is characterized by the massive use of talk box and vocoders. His vinyl release 'Westcoast Pioneers' on Da Source Records proved that he has mastered each individual genre.

Numerous reviews have praised his two follow-up albums, 'Released and Unreleased' volumes 1 and 2, in significant magazines and internet forums in the scene, confirming his status as the Funkmaster.

Through his hits 'Talkbox Fever' and 'Boogaloo Anthem,' Funkmaster Ozone has become a celebrated star of the scene in Asia. In the US, Ozone has also become increasingly popular as a featured artist. His talk box styles can be heard on various releases there, including those of Debonaire and Thee Suspect, as well as the tracks of more popular artists such as Boyz II Men and Lisha.

Although he is not as well-known in Germany, Funkmaster Ozone's live performances with the talk box and vocoder are particularly impressive. Inspired by George Clinton, Roger Troutman, The Egyptain Lover, Freestyle, Supermax, Prince and Paul Hardcastle, Ozone's music sounds as if all of these musicians got together and produced a collaboration. P-funk meets electro, or Bootsy Collins meets Afrika Bambaataa. This unique feat is best experienced at one of his live shows.

Breakfast Omlette for Funkateers

Ingredients:

- **750g** *(about 1½ lbs)* **potatoes**
- **75g** *(3 oz)* **bacon**
- **4 onions, chopped**
- **3 Tbsp oil**
- **3 eggs**
- **125g** *(4 oz)* **smoked ham**
- **2 Tbsp chives**
- **salt, pepper, sweet paprika, nutmeg**

- Wash the potatoes, then cover them with water in a pot and boil for them 20 to 25 minutes. Drain the water, then peel and slice.
- Cut the bacon, ham and onions into small cubes. Fry the bacon and the ham in a frying pan, add oil and sauté on high. Fry the onions until they turn glassy and then add the sliced potatoes and cook until they turn brown.
- In a bowl, mix the eggs and milk and season to taste with salt, pepper, paprika and nutmeg. Add the chives to the egg and milk mixture, and pour it over the fried potatoes. Cook on low heat until the bottom is slightly brown, turn over and cook on the other side.
- Sprinkle with chives and garnish with parsley. Enjoy a big cup of coffee with it and, if desired, a small tomato salad.

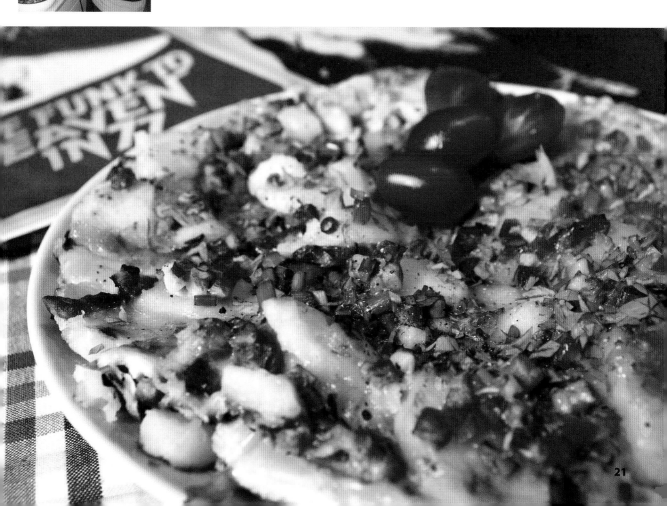

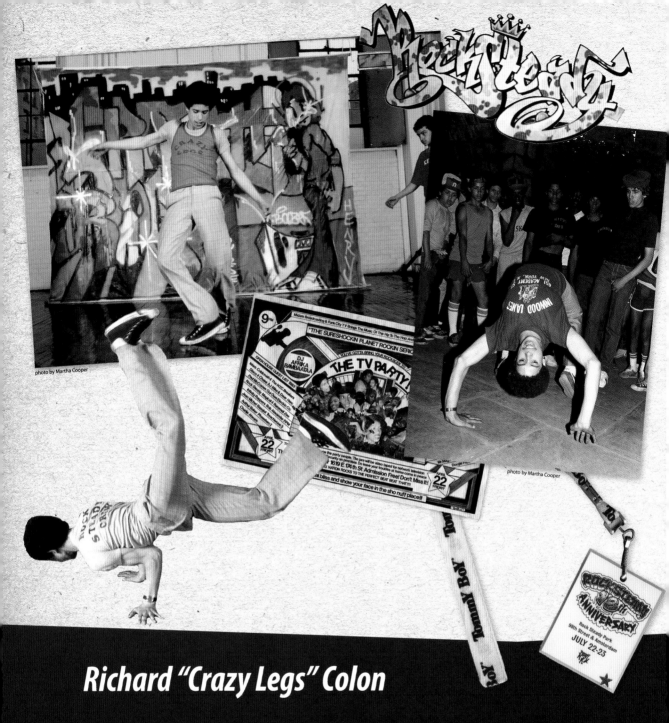

photo by Martha Cooper

photo by Martha Cooper

Richard "Crazy Legs" Colon

Crazy Legs recognizes breakdancing for what it is: an indigenous American art form. As the longtime leader of New York's renowned Rock Steady Crew, Legs is admired by b-boys and b-girls around the world for being an ambassador of Hip Hop culture.

Crazy Legs explains that b-boying was born out of poverty and struggle, and that its birthplace was the Bronx. Coincidentally—or maybe it was fate—that's where he found himself as a ten year old in 1976, a year when the harsh reality of inner-city life was often glossed over by the glitz of the US Bicentennial celebration.

As Crazy Legs remembers it, early b-boys danced to fill the empty hours in desolate, gang-infested streets, and more importantly, to express themselves. Their moves weren't mindless tricks, but rather creative responses to music. Nonetheless, this art was all about innovation. It was Crazy Legs and his peers who added acrobatic elements such as spinning to the dance.

In high school, a cheerleader announced that Richard Colon had "crazy legs," and the nickname stuck. While still a teenager, Legs landed a role that brought b-boying to the attention of the heartland. The hit movie 'Flashdance' not only featured him and other members of the Rock Steady Crew dancing in an alleyway, but Crazy Legs also performed as the breakdancing double for Jennifer Beals.

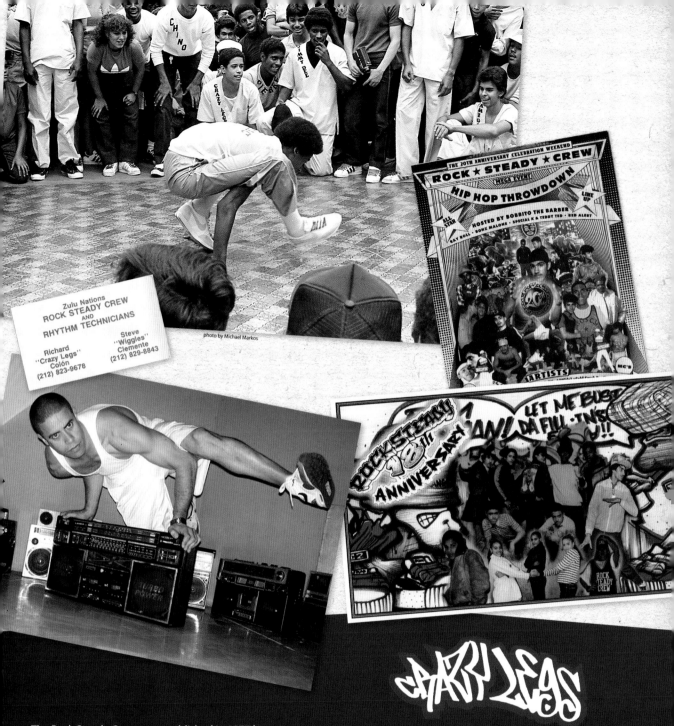

photo by Michael Markos

Zulu Nations
ROCK STEADY CREW
AND
RHYTHM TECHNICIANS

Richard Steve
"Crazy Legs" "Wiggles"
Colón Clemente
(212) 823-9678 (212) 829-8843

THE 20TH ANNIVERSARY CELEBRATION WEEKEND
ROCK ★ STEADY ★ CREW
MEGA EVENT!
HIP HOP THROWDOWN
HOSTED BY BOBBITO THE BARBER
RAY ROLL • BONZ MALONE • SPECIAL K & TEDDY TED • RED ALERT

ROCK STEADY 18th ANNIVERSARY

The Rock Steady Crew was established in 1977 by Bronx b-boys Jimmy D and Jojo. Only the best b-boys were allowed to get down with Rock Steady. Anyone who wanted to join the group had to battle an established crew member. Legs earned his spot at 13, but was forced to re-sign when his family moved to Manhattan. Eventually, Legs started a Manhattan chapter of Rock Steady, which created such a buzz that Jimmy D named him President of the entire Rock Steady organization; a title he's held ever since.

Truly a cultural phenomenon, the crew rapidly expanded to include artists, DJs, and other performers. In the early 1980s they launched tours to destinations like London and Paris, exposing Hip Hop to a global audience and setting a foundation for the culture.

With his countless appearances in films, television shows and music videos, Crazy Legs became the face of breakdancing. In 2001, Legs and other members of Rock Steady became the first b-boys to ever perform at Carnegie Hall. The Smithsonian has invited Legs to donate articles from his career to an exhibit honoring Hip Hop and its role in American history.

Baked Salmon with Fresh Dill & Secret Seasonings

This is one of Legs' favorite dishes that I make. He likes it because it's healthy, incredibly tasty and always comes out juicy—just the way he likes it. It's one of my personal favorites because it's a recipe that my step-mom in Hawaii taught me, and it's super fast and easy. The cleanup is easy, too!

Joselle Yokogawa, Legs' girlfriend

Ingredients:

- 1 full filet of fresh salmon, it should weigh anywhere between 700–900g *(25–32 oz)*
- 120g *(4 oz)* of fresh dill, chopped (or enough to cover the top of the entire filet)
- 30g *(1 oz)* "Secret Seasoning" (see recipe on page 111)

- Preheat oven to 220° C *(430° F)*. Place salmon filet, skin-side down, on a large piece of aluminum foil (make sure the piece of foil is long enough to give the filet ample room). Sprinkle the secret seasoning on top of the salmon filet, then cover the the salmon with the chopped dill.
- Place another piece of foil over the salmon filet. Gently 'envelope' or seal the salmon in the foil by folding the top and bottom edges together to create a pouch (be sure to give the filet room inside the pouch). Place the wrapped filet on a baking sheet and bake in the oven at 220° C *(430° F)* for 20–25 minutes.
- Remove from oven and let the salmon sit in the foil for five minutes. Remove the top layer of foil and serve!

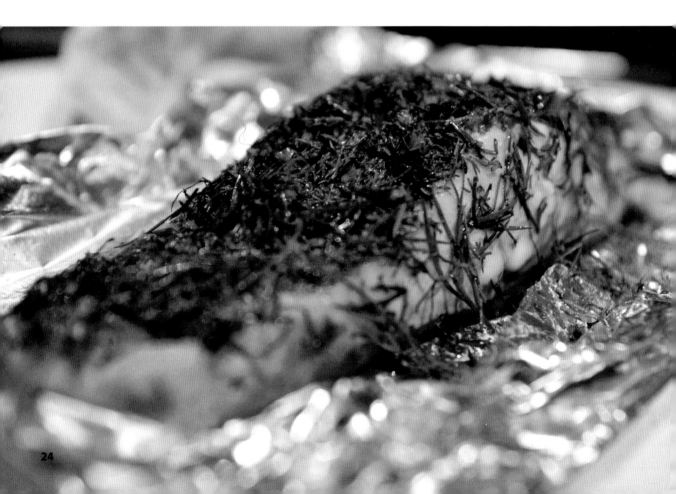

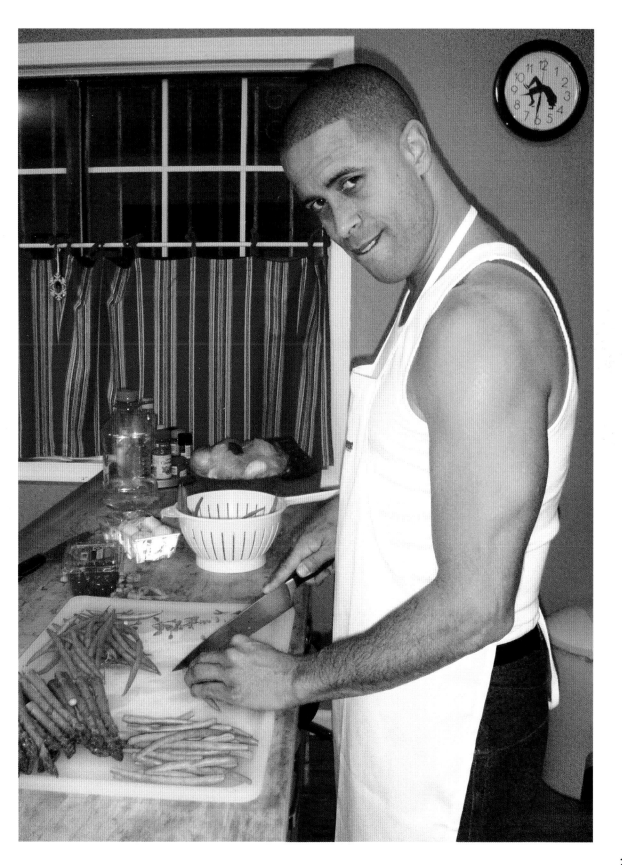

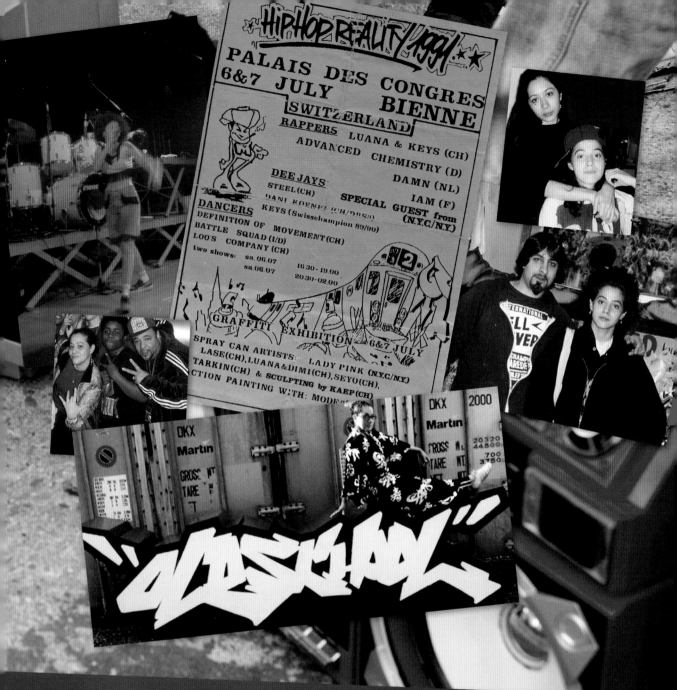

HIPHOP REALITY 1994

PALAIS DES CONGRES
6&7 JULY BIENNE
SWITZERLAND

RAPPERS LUANA & KEYS (CH)
 ADVANCED CHEMISTRY (D)
DEE JAYS: DAMN (NL)
STEEL (CH) SPECIAL GUEST IAM (F)
DANI KOENEL (CH/DRS3)
DANCERS KEYS (Swisschampion 89/90) from
DEFINITION OF MOVEMENT (CH) (N.Y.C/N.Y)
BATTLE SQUAD (I/D)
LOO'S COMPANY (CH)
two shows: sa.06.07 16.30-19.00
 sa.06.07 20.30-02.00

GRAFFITI EXHIBITION 6&7 JULY

SPRAY CAN ARTISTS: LADY PINK (N.Y.C/N.Y)
LASE (CH), LUANA&DIMI (CH), SEYO (CH),
TARKIN (CH) & SCULPTING by KAEP (CH)
ACTION PAINTING WITH: MODE2

Luana

Luana, aka Chéjah, or by birth Stephanie Cea, is a leading force and pioneer in Switzerland's Hip Hop scene. An MC and singer from Basel, she was inspired by the Rock Steady Crew and started writing rhymes in 1983. She went on to become a Zulu queen and member of the Zulu Nation.

In 1989 Luana started off as a funk, soul and rap singer with the band Pol Corsa. She had her first record debut with the song 'Ladies in da House'. She debuted on 'Fresh Stuff 1', the first Swiss rap compilation vinyl in 1990. With this release Luana's reputation grew, and her performances at the Coupole in Biel during the early 90s

allowed her to share the stage with groups like Duty Free, I AM, NTM, Lord Finesse, Sens Unik and many others. Her recordings include radio jingles for DRS3 in Los Angeles with Emel, and a gospel, rap and R&B maxi-single 'G.O.D.' / 'I had a dream'. As a competition participant, she received a nomination at the Holy Hip Hop Awards in Atlanta and the gold medal at the Song-Composer Contest in Holland. She's collaborated on stage with Afrika Bambaataa, Kool DJ Herc, Grandmaster Flash, Grandmaster CAZ, Prince Whipper Whip, and Mad Professor; and has opened for De La Soul, Neneh Cherry, Warren G., Run DMC, Tic Tac Toe, Joe Cocker, Joan Baez, Mr. President, N'SYNC, 2–4 Family, 2Unlimited, Kurtis Blow and the Furious Five. Most of Luana's rhymes and songs are in English.

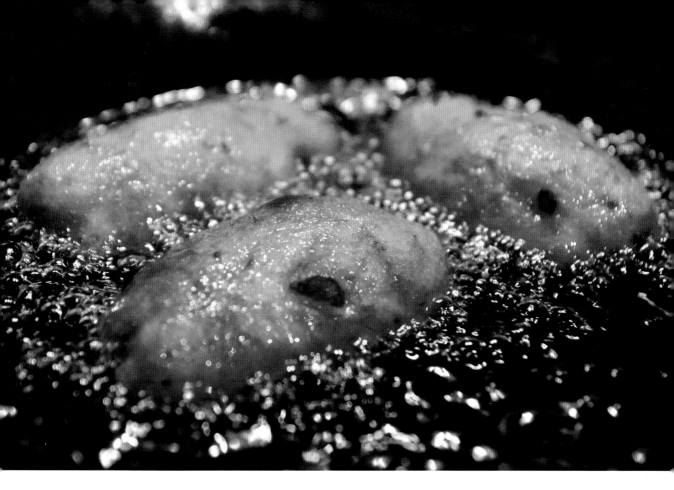

Zeppole Calabresi
Mom's traditional recipe from Calabria

Ingredients:

- **1kg** *(about 2 lbs)* **potatoes**
- **1kg** *(about 2 lbs)* **flour**
- **2 packs of yeast**
- **1½ tsp salt (or to taste)**
- **sunflower oil and olive oil**

- Dissolve two packages of yeast into lukewarm water with salt.
- Boil, peel and puree the potatoes.
- Mix the potatoes and flour.
- Poke a hole in the middle of the dough and pour the yeast mixture inside.
- Mix it all together and knead, knead, knead…
- Set it aside for an hour in a large container with a damp dishcloth on top.
- After an hour, knead the dough again and roll it into small "sausages." Normally these are then shaped into little Christian fishes.
- Heat a fifty/fifty mixture of sunflower oil and olive oil in a deep pan or fryer and fry until golden brown.

Second variation, with sardines:
- Use half the dough from the regular recipe to cook this version.
- Mix the dough with a little water. Allow it to rise again for an hour.
- Knead the dough and make "burger-sized" discs. Simply press the sardines into the middle of the dough circles.
- Fry, and then you're finished!

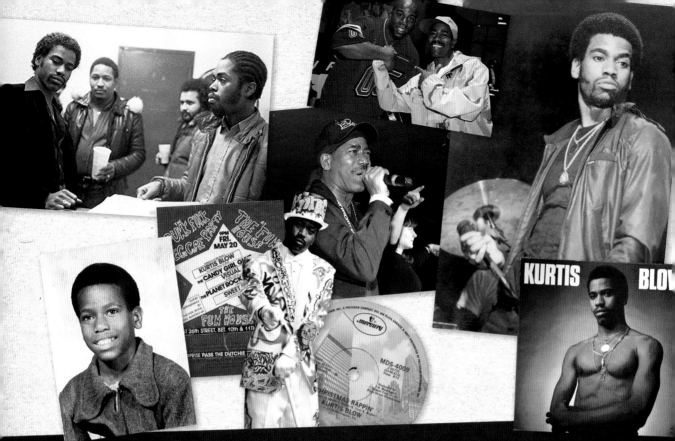

Kurtis Blow

Kurtis Blow, one of the founders and creators of recorded rap, stands as an emerging leader in a new generation of rappers characterized by street sense, social criticism and commercial savvy. In 1979, at the age of twenty, Kurtis Blow became the first rapper to be signed by a major label. Mercury released the album 'Christmas Rappin,' which sold over 400,000 copies and became an annual classic. Its gold follow-up, 'The Breaks,' helped ignite an international rap attack. He released ten albums in eleven years: his full-length debut was entitled 'Kurtis Blow' and his second was the Top 50 Pop Album 'Deuce,' which was a big hit across Europe. Other albums included 'Party Time,' which featured a pioneering fusion of rap and go-go; 'Ego Trip,' which includes the hits '8 Million Stories,' 'AJ' and 'Basketball.' In 1985 he released 'America,' which received an MTV Monitor Award for its video innovations. From this album, the song 'If I Ruled the World' became a top 5 hit on Billboard's R&B chart.

Besides his own work, Kurtis has also been responsible for rap hits by Run DMC and The Fat Boys. Run began his career by being billed as "the son of Kurtis Blow." Love Bug Starski, Sweet Gee, Dr. Jekyll and Mr. Hyde, Full Force, Russell Simmons and Wyclef Jean have all been produced by, or have worked with Kurtis.

His participation as a host, actor, music director or producer in several movies, including Leon Kennedy's 'Cry of the City' and the hit film 'Krush Groove,' has won him much acclaim. As host and co-producer of an international film production focusing on the West Coast gang scene (Das Leben Amerikanischer Gangs–the life of American gangs), Kurtis Blow crossed international waters for inner city jus-tice (1995). As host and associate producer for 'Rhyme and Reason,' a Miramax film, Kuris Blow gave an informative account of the present status of Hip Hop (1998). He was also an active participant in the blistering Artist Against Apartheid record 'Sun City.' Kurtis Blow speaks out emphatically against alcohol and drugs. Kurtis' innate ability to reach people is also evident in his role as spokesperson for The National Ad Counsel. He is an integral part of its youth campaign and can be seen and heard in the media nationwide as the first to 'say no to drugs.'

As a timeless Hip Hop legend, Kurtis Blow was featured in a Hip Hop display at the Rock and Roll Hall of Fame in 1996, which still stands today. He was also honored by the American Society of Composers, Authors and Publishers at a gala affair in 1999. In 2002, after 9/11, Kurtis went to the Middle East to tour 17 Armed Forces bases to bring a little bit of home to the troops stationed there. "It was a tour I will never forget," said Kurtis: "I did the Bob Hope thing." Here are many of the 'firsts' credited to Kurtis Blow: the first rapper to sign to a major label, first certified gold record for rap ('The Breaks'), first rapper to tour the US and Europe (with The Commodores, 1980), first rapper to record a national commercial (Sprite), first rapper to use the drum machine, sample and sample loop, first rap music video ('Basketball'), first rap producer (Rap's Producer of the Year from 1983-'85), first rapper featured in a soap opera ('One Life to Live') and the first rap millionaire.

Kurtis Blow helped legitimize Hip Hop, and now, he intends to help redeem it. Having made a deep commitment to the ways and teachings of Jesus Christ, Kurtis has been attending Ministry classes at NYACK College. As co-founder of the Hip Hop Church, Kurtis serves as rapper, DJ and worship leader.

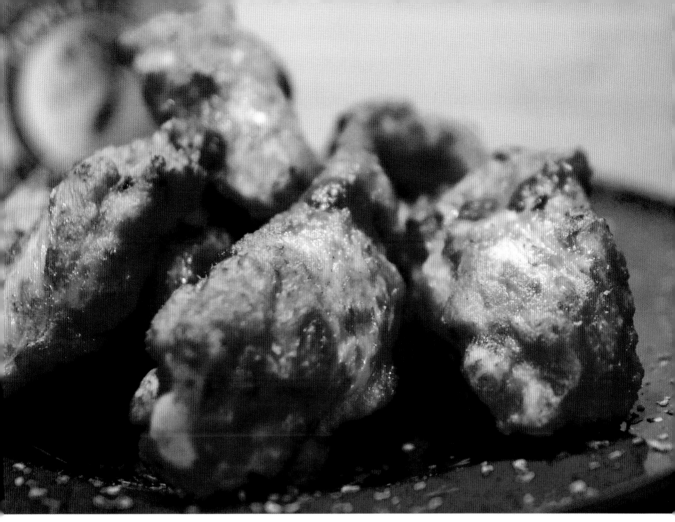

Kurtis Blow's Hot Wings

Hot wings:

- 1kg *(2½ lbs)* **of chicken wings**
- 3 Tbsp **of vegetable oil**
- 1 Tbsp **freshly minced garlic**
- 2 Tbsp *(30ml)* **of white vinegar**
- 5 Tbsp *(75ml)* **of hot sauce**

Sauce:

- 4 Tbsp *(60ml)* **of hot sauce**
- 6 Tbsp **of butter**
- 6 Tbsp *(90ml)* **of vinegar**

- Cut off the tips of the wings, wash with cold water and dry.
- In a large pan, mix hot sauce, oil, vinegar and garlic. Add wings and coat them well.
- Let it marinate for at least 30 minutes.
- Put wings on a broiling pan and cook in oven broiler until crispy, turning once to cook both sides (10–15 minutes for each side). While wings are cooking, make the sauce by mixing the ingredients in a pot over low heat.
- When the wings are done, spread the sauce over them and enjoy!

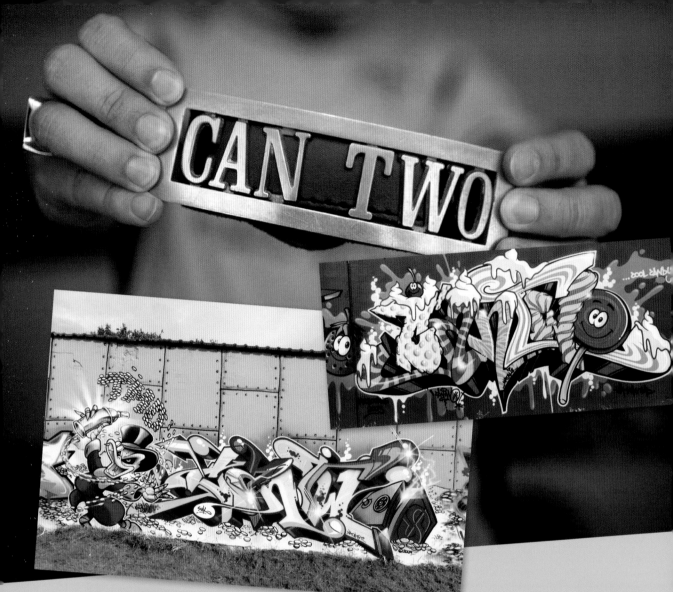

Can Two

At the tender age of seven, Can2 had a driving need to artistically improve his school desk and schoolbooks with his own illustrations. In 1983, he made his first fledgling attempts at spraying in his hometown of Mainz, drawing his inspiration from the mecca of graffiti, the Bronx. Can2 has represented the Bronx style of the early 80s—in his view the only true graffiti style—from the very start.

A few years after his first forays into graffiti writing, he began receiving art commissions and was invited to graffiti jams throughout Germany. As he gained practice and grew more skilled at his craft, he was invited to participate in graffiti events worldwide and he lead graffiti workshops in different cities. Then, starting in 1992, he began his studies in graphic design in Hamburg. Around the same time, he founded the graffiti crew the Stick up Kids.

In 1998 he began freelancing with the Oxygen Art Agency, where he would later design new spray paint colors and cans to fit the needs of graffiti artists (Oxygen Colors). Can2 later established his own clothing label

(the Stick up Kidz) and founded an agency for illustration, graphic design, web design and aerosol art. In 2005, together with the writers Bomber and Atom, he established the graffiti agency Absolute Graffiti.

Can2 has participated in dozens of group and solo exhibitions, has been a judge for many graffiti competitions and has done art and design work for companies such as Coca Cola and Adidas. In 2007 he participated in painting the world's biggest billboard graffiti (60m x 12m) in Dubai, which made it into the 'Guiness Book of World Records.' In addition, he was appointed the Art Ambassador for Germany at the World Expo's German Pavilion in Shanghai in 2010.

Can2 sprays letters that have a dynamic impact on walls. With their unique diorama effect, Can2's characters are brought to life through his shading techniques and distinctive styles. Can2, a writer with 23 years of graffiti experience, continues to take his art to new and unexpected places. His drive to make pieces both large and small, and to collaborate with artists from all over the world, is sure to keep him going for many years to come.

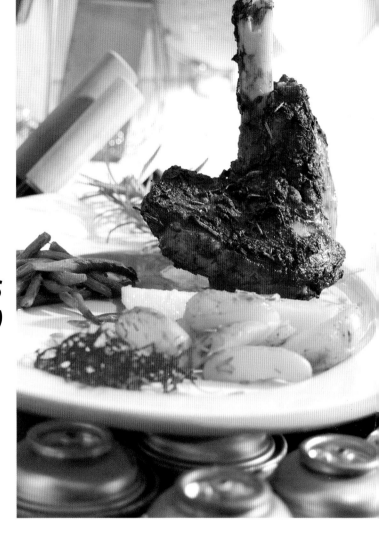

Lamb Shanks
(Lammstelzen)

Ingredients:

- 2–3 lamb shanks
- juice from half a lemon
- several garlic cloves
- olive oil
- 1 onion
- cornstarch
- whole (heavy) cream
- 1 glass of red wine
- To taste: mustard, rosemary, thyme, salt, pepper

- First, make a marinade with the mustard, lemon juice, several cloves of garlic, rosemary, thyme, olive oil and pepper. Cover the shanks with this mixture and then put them in a plastic bag in the fridge for at least 6 hours.
- Then, remove the shanks from the bag, put them on a baking sheet and roast them in the oven at a low temperature (150° C / 300° F maximum) for 2 ½ hours.
- Just before you are ready to eat, remove the shanks and scrape off the juice and herbs from the baking sheet, setting this aside for the gravy. Next, fry an onion in a small saucepan, add the drippings from the lamb shanks, red wine and salt. Bring it to a boil and thicken the gravy (if necessary) with cornstarch. Add as much cream as you like for desired thickness and taste.
- In the meantime, put the shanks back in the oven and set the oven to 'grill' at a somewhat higher temperature to brown the shanks. Cook each side for 10 minutes, or until brown.
- After tasting the gravy to make sure it has enough flavor, the shanks are ready to eat. They can be served with mashed potatoes and green beans, or tiny boiled potatoes, which are peeled and fried in butter with rosemary.

I buy frozen New Zealand lamb shanks at the supermarket. Alternatively, I order them ahead of time from a Turkish butcher, where they are cut off a leg of lamb (the lower part). Most people eat 1 lamb shank but I generally make an extra 2 or 3 just in case someone wants seconds, and leftovers are delicious.

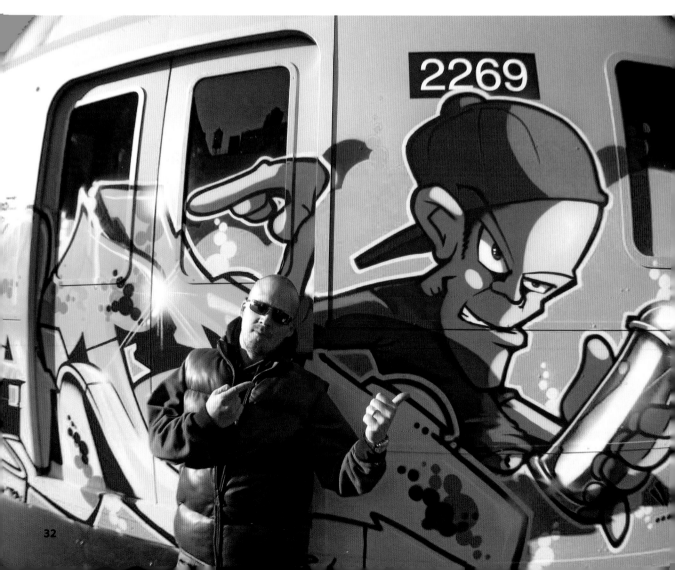

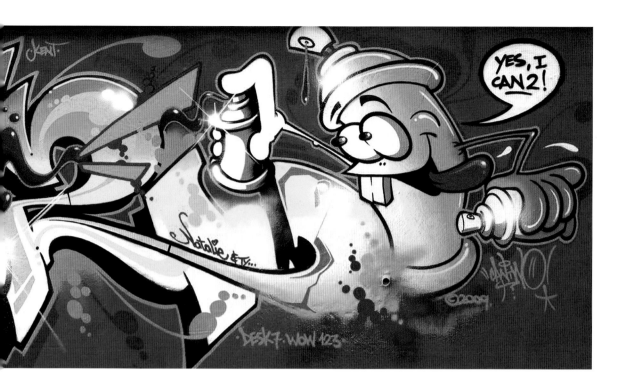

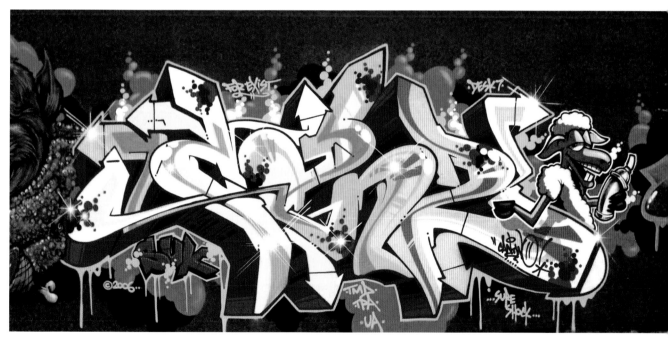

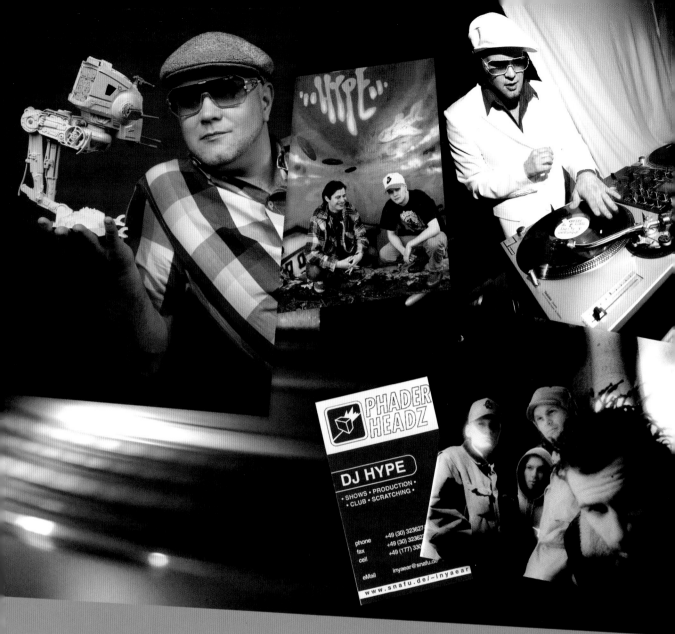

Marc Hype

Marc Hype started his career as a DJ in 1988, drawing his inspiration from the late artist Jam Master Jay. In a career spanning decades, Hype has had numerous releases and tours, collaborating and recording with artists such as Juice Crew legend Masta Ace, Souls Of Mischief, Edo G., Zion I, DJ Z-Trip, Patrick Pulsinger, Killa Kela, Akrobatik and Mr. Lif. He's also participated in various competitions and won the ITF championships in '98 and '99.

With a record collection and artistic talent that continue to expand, Hype's deck selection and production has a unique groove.

In 2004 he met pianist and artist Jim Dunloop. Discovering a shared passion for music, they began to collaborate on shows and productions, releasing their first vinyl under the Milk Crate label, which featured the songs 'The Antique Anthem,' 'Bombay Raw' and 'Finale 74.' After the success of this album, they released a cover version of Babe Ruth's 'The Mexican.'

In 2009 Hype and Dunloop's album 'Stamp out reality' was released by Melting Pot Music, featuring legendary artists Blowfly, Mr. Complex, Flomega and Lady Daisey. Hype made a strong name for himself worldwide by hosting the 'Rap History Berlin' series, several SoulClap! events and touring around Europe and the world with stops in NYC, Japan, Hong Kong, China, Cambodia, Vietnam, Singapore, United Arab Emirates, Russia, Israel, India and Australia.

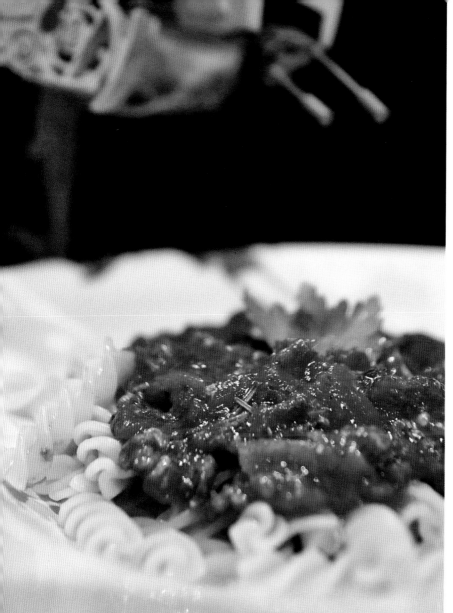

Ingredients:

- 500g *(18 oz)* Fussili or other pasta
- 150g *(5 oz)* ground beef
- 100g *(4 oz)* ground veal
- 100g *(4 oz)* ground pork
- 50g *(2 oz)* Salsiccia (substitute: Italian sausage)
- 2 Tbsp olive oil
- 1 bunch fresh flat-leaf parsley
- 1 bunch basil
- 1 bunch oregano
- 3 sage leaves
- 1 large onion
- 3 garlic cloves
- 500g *(18 oz)* canned tomatoes
- 2 Tbsp triple concentrate tomato paste
- 1 glass of red wine
- 125g *(4 oz)* parmesan cheese
- salt, pepper and cayenne pepper

Hype's Fussili

Finely chop the onion, garlic, sausage and all of the herbs. Heat oil in a pan and sauté sausage, herbs, onion and garlic for about 4 minutes. Add the ground meat and brown well. Pour in red wine and let boil. Stir in canned tomatoes and tomato paste and let simmer for about 30 minutes. In the meantime, cook the pasta. Put in a bit of the parmesan and stir the meat sauce. Once everything is melted, add the rest of the parmesan and season with salt and pepper to taste. Mix the noodles with the sauce to finish.

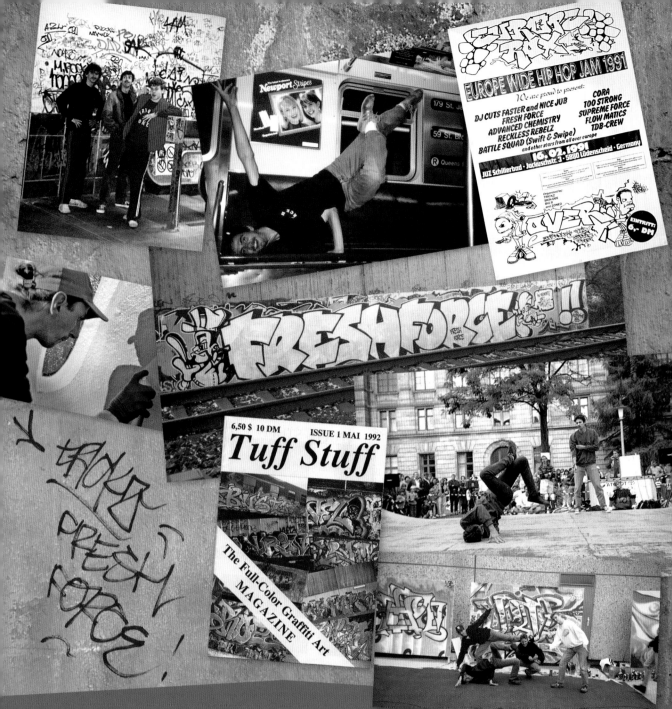

Fresh Force

Gess, Steeze, Ten Two, Speedy and Trickz make up Fresh Force, a breakdance crew from Aschaffenburg and one of the pioneer b-boy crews of Germany. They have won several breakdance competitions throughout Germany as well as placing first in the European championship.

Their first of many trips to New York City was in 1990. During these trips they performed and painted with other people from the Hip Hop scene, such as Seen and Vic 161. It was in NYC that they met Henry Chalfant and were allowed to see his 'holy photos.'

In 1992 they published the magazine 'Tuffstuff,' the first full-color graffiti magazine in the world. It received much attention in the scene and played a significant role in the development and globalization of European graffiti culture. The last issue was published in 2000.

Fresh Force opened Sixstep, a Hip Hop and underground shop in Aschaffenburg, in 1995. This store still exists today, but in a different form and under different management. They also organized events such as 'Ostercamp' (Easter camp), the first training camp of its kind, which was attended by breakdancers from all over Germany.

In addition, Fresh Force has participated in numerous breakdance competitions and graffiti jams. Through their dedication to the scene they have achieved international fame and have done commissioned works for companies such as Dresdener Bank and the Hilton.

Flour Dumplings

Meatballs:

- about ½ kg *(1 lb)* ground beef
- 1–2 medium sized onions
- 1–2 cloves of garlic
- 1 handful of fine breadcrumbs
- 1 bun, soaked in water
- salt
- pepper
- paprika powder
- 1–2 eggs
- vegetable or sunflower seed oil

Cucumber salad:

- 1 cucumber
- 2 large cans of evaporated milk
- salt & pepper (to taste)

Flour dumplings:

- 500g *(4 cups)* flour
- 2 eggs
- 1 tsp salt
- 1 dash nutmeg
- 250ml *(slightly more than 1 cup)* milk

Meatballs

Mix meatball ingredients (preferably by hand) and form the meat into balls. Mixture should not be too dry or too wet. Fry in vegetable oil and enjoy.

Cucumber salad

- Peel the cucumber thinly and slice.
- Place the cucumber slices in a bowl, mix them with 2 pinches of salt and set aside for a short while. Add 2 large cans of evaporated milk, stir and add salt and pepper as desired.

Flour dumplings

- Sift the flour into a large bowl and add the eggs. Add the salt, pepper and nutmeg as well as some of the milk.
- Stir with a large wooden spoon. Continue to add milk until you have a thick dough that forms bubbles.
- While preparing the dough, boil broth or salt water. Use a soup spoon to portion the dough (for better handling, dip the spoon into hot water beforehand) and drop spoonfuls of dough into the boiling broth or salt water. Reduce the heat to medium. The dumplings are done as soon as they rise to the top.

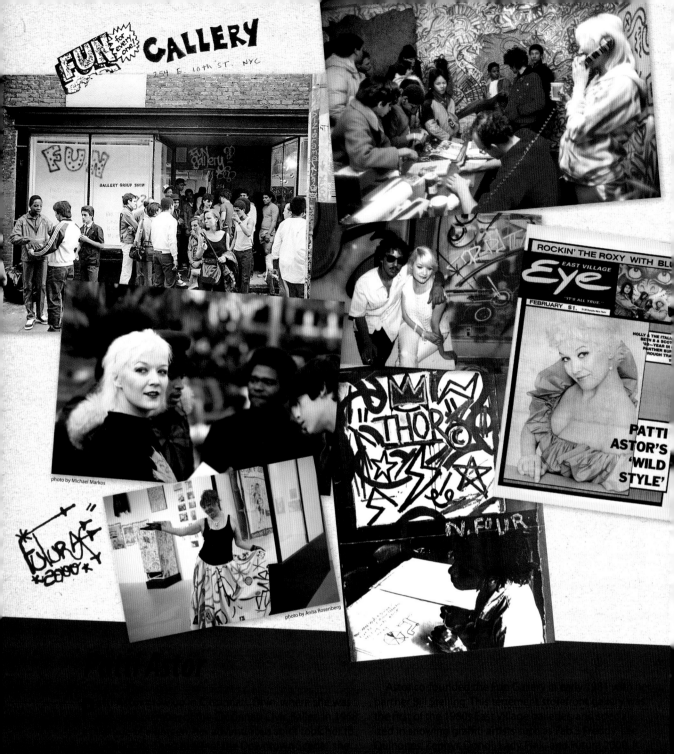

FUN *for every one!* GALLERY
254 E. 10th ST. NYC

FUN
GALLERY GROUP SHOW

photo by Michael Markos

photo by Anita Rosenberg

ROCKIN' THE ROXY WITH BLU

EAST VILLAGE
Eye
"IT'S ALL TRUE."
FEBRUARY $1.

PATTI
ASTOR'S
'WILD
STYLE'

Down Home Apple Crisp

This is a great dessert, since once you get the hang of it you can make it in any size with any fruit in season. For example, ripe peaches rock.

Ingredients:

- 8 medium (6 large) Granny Smith crisp green apples
- 1½ tsp cinnamon
- 1 kid snack box raisins (optional)
- 1 stick (125g / ½ cup) chilled, unsalted butter
- 85g *(¾ cup)* flour
- 170g *(¾ cup)* dark brown sugar
- 1 small bag (30g / ¼ cup) pecan "chips" or chopped pecans
- vanilla ice cream
- gold rum or cognac (optional)

- Preheat oven to 175° C *(350° F)*.
- Use a 28 x 18 x 4 cm *(11 x 7 x 1½ in)* Pyrex rectangular baking dish for cooking the apple crisp.
- Peel apples, cut in quarters, core and slice crosswise in about 0.5 cm *(¼ in)* slices, and place in a medium bowl.
- Toss well with cinnamon and optional raisins (use your hands!) and spread the pieces out in the baking dish.
- In the same bowl, cut the stick of butter into small cubes, and add flour and dark brown sugar.
- Crumble the flour, butter and sugar together between your thumb and index finger (like counting cash money!) into a coarse mixture, then mix in the pecans.
- Sprinkle evenly over the apples in the pan.
- Bake for 45 minutes or until the top is crisp and brown and the apples are bubbling and tender.
- Let it cool for 15 minutes, serve with a scoop of vanilla ice cream and love.
- For a whole lotta love, top with a splash of rum or cognac like we do "down home." Serves 6–8 people.

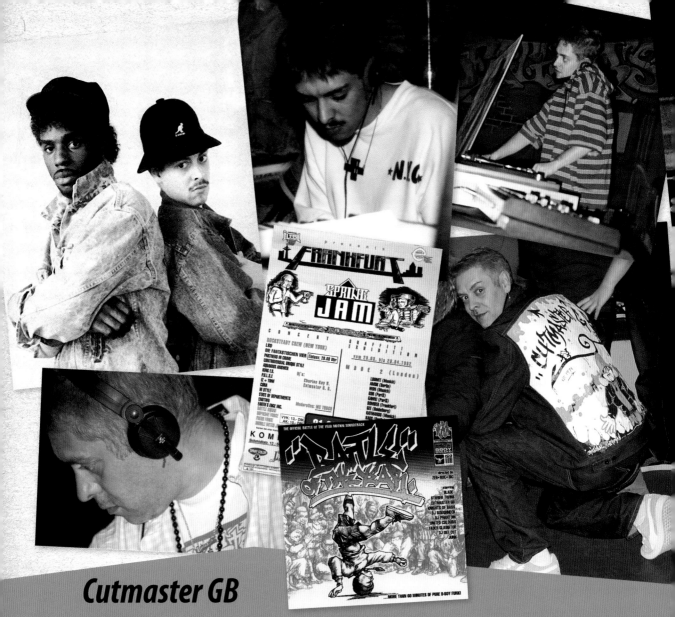

Cutmaster GB

Gerry Bachmann, aka Cutmaster GB, was born in Frankfurt, where he still lives with his family. He started writing graffiti in 1979 after visiting New York for the first time. In 1980 he began b-boying, and danced at the Frankfurt premiere of 'Wild Style' in 1984. In the same year, he painted the first U-Bahn whole car in Germany with his partner and good friend Spot. It was around this time that he became a member of the Universal Zulu Nation and the Universal Movement.

In 1984, Cutmaster GB started his career as a DJ. As the DJ of the group Bionic Force, he's performed worldwide, including at the first German Jam in Mainz in 1988.

Bionic Force released the first serious rap twelve-inch in Germany and was the first German rap group to get a contract with a major record label (EMI).

Cutmaster GB also founded one of the first Hip Hop labels in Germany, Earth's Edge Recordz, in 1991. He organized the Spring Jams of 1992 and 1994 in Frankfurt, which were two of the largest European jams at that time. The Spring Jams have played a decisive role in connecting Hip Hop artists worldwide.

In addition to his solo recordings, Cutmaster GB has released albums with groups such as Bionic Force, MC Cal-Ski and the 'Battle of the Year (BOTY) Samplers.'

Cutmaster GB was the only artist ever to be represented on all of the BOTY samplers In the early years.

He made music for the 'Fett MTV' Hip Hop TV show and has organized diverse graffiti exhibits. Together with his label Earth's Edge Recordz and the artists MC Cal-Ski and Fresh Force, Cutmaster GB performed as the opening act on the 'Godfathers of Rap Tour' (Grandmaster Flash, Kurtis Blow & Sugarhill Gang) in 1992, which toured throughout Germany. His twelve-inch 'Ghetto Michel Angelo,' released in 1992, is considered to be a hymn to graffiti writing, and his single 'Dedication,' released in 1997, was the forerunner of today's b-boy tracks.

Diverse DJ performances worldwide round out the image of Cutmaster GB, who is one of a handful of godfathers of the German Hip Hop scene. MZEE named Cutmaster GB Germany's first Hip Hopper. Daddy O's (Stetsasonic) cousin, Doctor D said: "He is Germany's Kool DJ Herc."

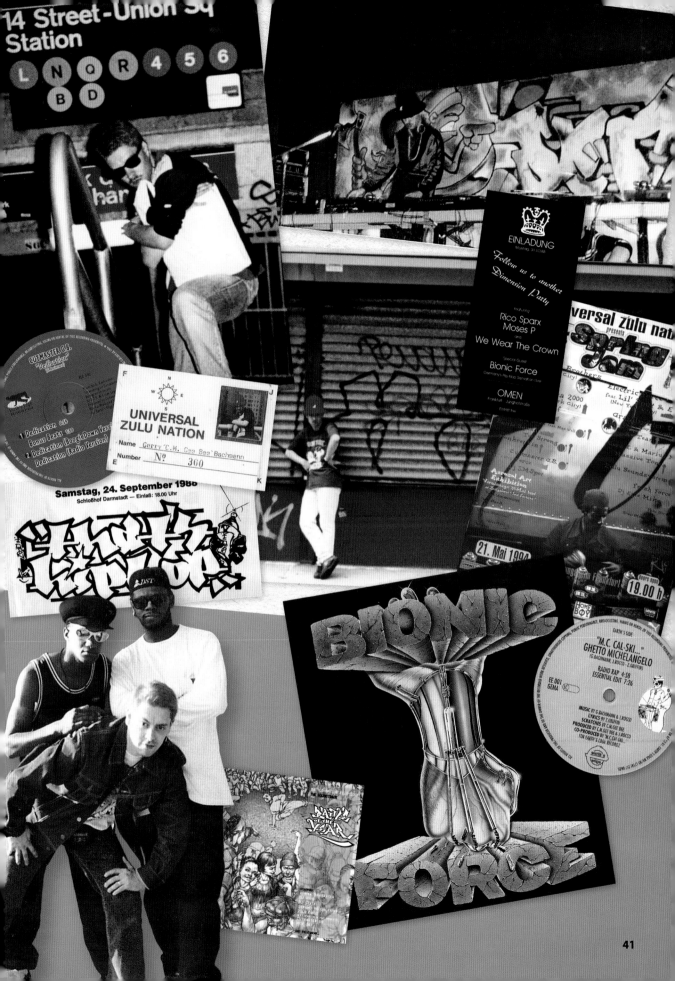

14 Street-Union Sq Station

L N Q R 4 5 6
B D

CUTMASTER G.B. "Dedication"

1 Dedication 6:51
Bonus Beats 1:30
2 Dedication (Boogie Down Version)
Dedication (Radio Version)

UNIVERSAL ZULU NATION

Name Gerry "T.M. Gee Bee" Bachmann
Number N° 300

EINLADUNG
Montag, 31.10.88

Follow us to another Dimension Party

featuring
Rico Sparx
Moses P
and
We Wear The Crown

Special Guest
Bionic Force
Germany's Hip Hop Sensation live

OMEN
Frankfurt - Junghofstraße
Eintritt frei

universal zulu nation presents
Sypha Jam

Samstag, 24. September 1988
Schloßhof Darmstadt — Einlaß: 18.00 Uhr

21. Mai 1994

19.00 h

BIONIC FORCE

EARTH'S SIDE
"M.C. CAL-SKI..."
GHETTO MICHELANGELO
(G.BACHMANN, J.ROCCO - Z.GRIFFIN)
RADIO RAP 4:58
ESSENTIAL EDIT 7:26

MUSIC BY G.BACHMANN & J.ROCCO
LYRICS BY Z.GRIFFIN
SCRATCHES BY Z.GRIFFIN
PRODUCED BY CAL GEE BEE
CO-PRODUCED BY "M.C. CAL-SKI"
FOR EARTH'S DISK RECORDZ

EE 001
GEMA

41

Crab Fritters
with tomato butter, katveg & sweet potatoes

Crab Fritters:

- 450g *(16 oz)* crab meat
- 4 medium-sized shrimp
- 4 tsp *(20ml)* buttermilk
- ½ tsp black pepper
- ½ tsp salt
- 2 red chilis
- 1 tomato
- 3 garlic cloves
- 50g *(¼ cup)* bread crumbs

- Remove the seeds from the chilis, and seed and skin the tomato. Set the tomato skin aside.
- Put all the ingredients in a mixer or food processor and puree.
- Form the mixture into little balls (4.5 cm / *1¾ in*).
- Fry the balls in hot oil (180–200° C / *350–390° F*) for about 3 minutes. When they turn golden brown they are ready to serve.

Tomato Butter:

- 1 tsp thyme
- 200g *(7 oz)* butter
- 1 tsp marjoram
- 4 garlic cloves
- 50g *(2 oz)* fresh cilantro
- 1 tsp tomato skin
- 150ml *(4 oz)* Heinz ketchup

Puree all the ingredients except the butter and cook them over low heat for about 6 minutes. Don't forget to stir. Turn the heat down and add the butter, be careful that the butter does not get brown.

Katveg:

- 200g *(7 oz)* green beans
- ½ mango
- 1 onion
- 1 tsp tomato puree
- 1–2 red chilis (seeded)
- 1 tsp brown sugar
- 150ml *(5fl oz)* water
- 1 garlic clove
- 4 tsp Thai sweet chili sauce
- 1 tsp olive oil

Boil the green beans for about 15 minutes (they should still be a little bit crunchy). Cut the onion and the mango into pieces (1 cm / ½ in). Dice the garlic. Heat up the olive oil in a pan and add the onion, mango and garlic. Stir it for 1 minute. Put the rest of the ingredients in and let them cook on medium heat for 10 minutes.

Sweet Potatoes:

- 3 normal sweet potatoes (the orange ones are best)
- 250ml *(1 cup)* fresh orange juice
- 1 tsp cinnamon
- 5 Tbsp brown sugar
- 1 tsp lime juice

Peel and slice the sweet potatoes (0.5 cm / *0.2 in* thick). Mix the orange juice with the cinnamon and the brown sugar. Put everything together into a casserole dish. Cover the casserole dish and place it into a stove pre-heated to 175° C *(350° F)*. Stir occasionally. After 1 hour, pour the lime juice over the potatoes. Then, raise the temperature to 225° C *(435° F)* and cook for 15 minutes.

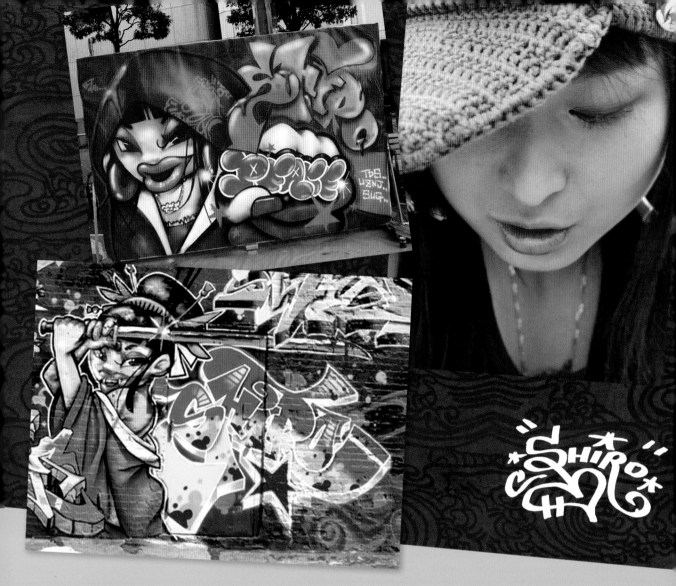

Shiro

Shiro, who is a member of the crews GCS (Japan), TDS (USA), Universal Zulu Nation (Japan) and SUG (inter-national) is a female graffiti artist from Japan. She began painting in 1998, in Shizuoka, Japan. Shiro's colorful art-work is a reflection of her love for true Hip Hop. Over the years she has been inspired by Hip Hop culture and old school graffiti styles. Her devotion to graffiti art afforded her the opportunity to work with many great graffiti art-ists, an experience which has inspired Shiro and fuelled her creativity. As an international artist, she continues to be spurred on by the strength and creativity of old school Hip Hop.

Deciding to stay in New York and develop her talent as an artist, Shiro lived in Brooklyn and Queens from 2003 to 2005, where she could be found painting in the city on a regular basis. She has performed in various live painting events, participated in gallery art shows and has been a part of graffiti crew gatherings in both New York and Japan.

In Japan, Shiro has worked with people in the Hip Hop industry to organize graffiti shows and live painting events in her hometown of Shizuoka, as well as participating in painting events in surrounding areas. In addition to her murals, she has worked on canvases and illustrations and has designed and produced original stage decorations.

In addition to her career as an artist, Shiro is also a part-time nurse, caring for elderly people who are completing the cycle of life. In nursing, she is able to share her gifts of empathy and compassion with those who are in need. It is the unique combination of nursing and painting that keeps her soul and mind in sync and fuels her artistic expression. She is also an avid motorcyclist as well as an ex Judo champion.

All of these things combine to create a unique indi-vidual with a gift for creative expression. Shiro's artwork revolves around strong females. Her characters depict the essence of motherhood and the beauty of newborns, be-cause in her words, mothers bring new life into the world. She is inspired by this strong female spirit in every aspect of her life, and strives to represent the potent energy of womanhood in her artwork.

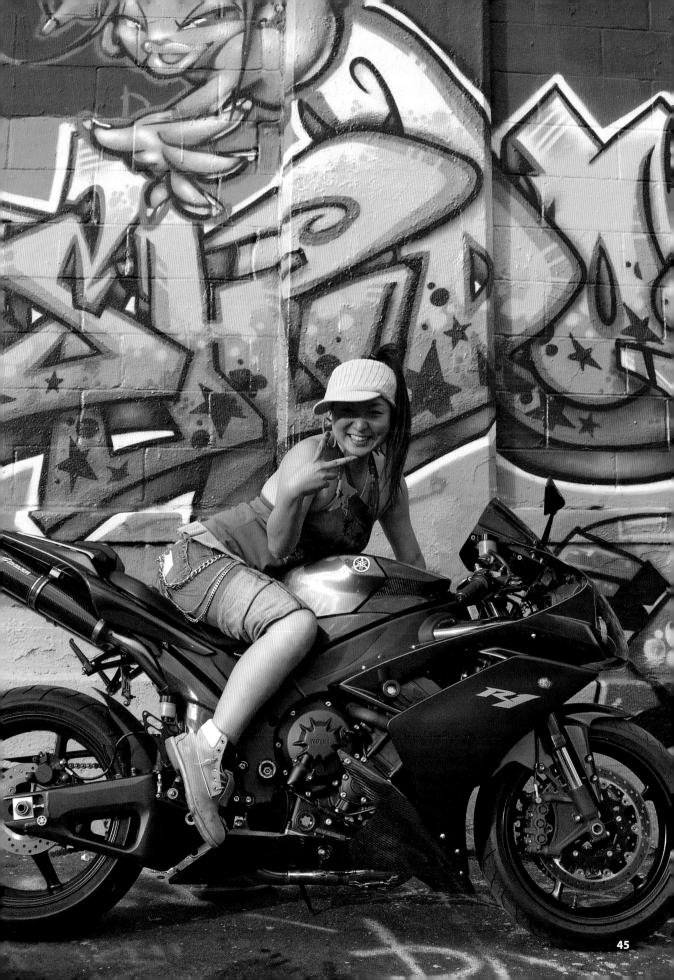

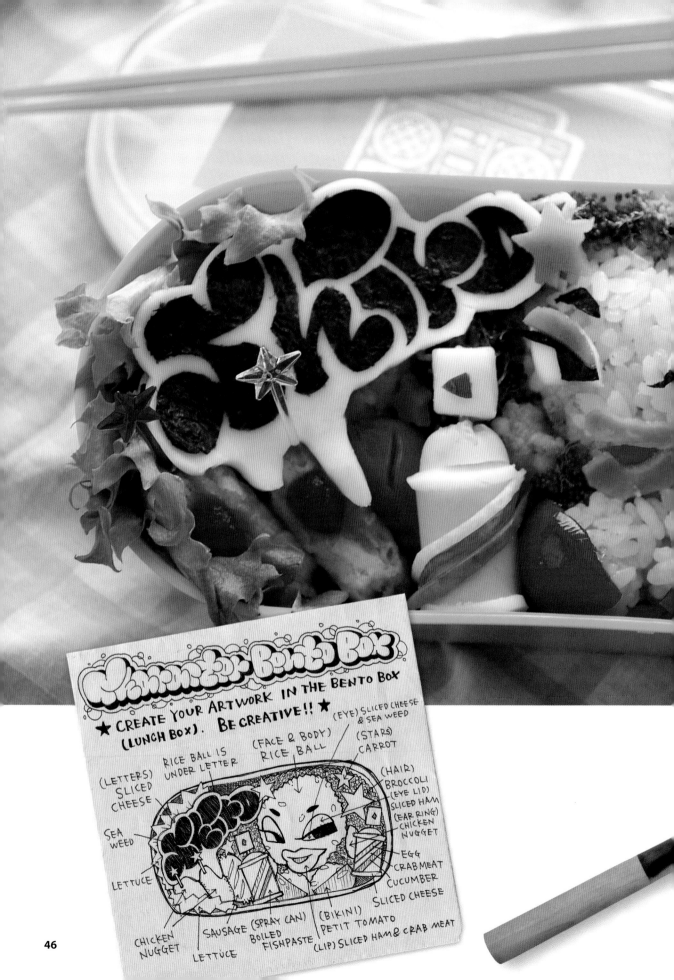

★ CREATE YOUR ARTWORK IN THE BENTO BOX (LUNCH BOX). BE CREATIVE!! ★

(EYE) SLICED CHEESE & SEA WEED

(FACE & BODY) RICE BALL

(STARS) CARROT

(LETTERS) SLICED CHEESE

RICE BALL IS UNDER LETTER

(HAIR) BROCCOLI
(EYE LID) SLICED HAM
(EAR RING) CHICKEN NUGGET

SEA WEED

EGG
CRAB MEAT
CUCUMBER

LETTUCE

SLICED CHEESE

CHICKEN NUGGET

SAUSAGE (SPRAY CAN) BOILED FISHPASTE

(BIKINI) PETIT TOMATO

LETTUCE

(LIP) SLICED HAM & CRAB MEAT

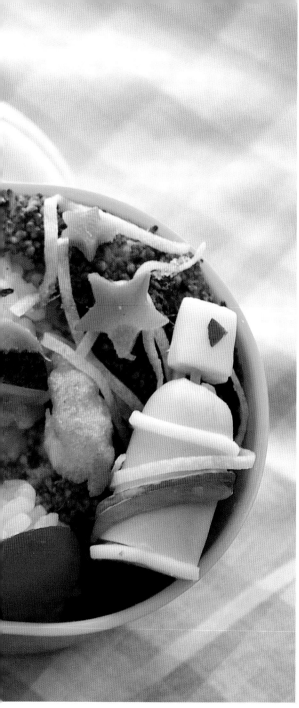

Bento

Bento (弁当 *bentō*) is a packed lunch or dinner which is common in Japan. A traditional bento includes rice, vegetables and fish or meat in a closed box container, made of plastic, wood or lacquerware. While bento can be bought at snack shops, grocery stores and other places in Japan, many people still prepare bento meals for themselves or their loved ones.

One special type of bento is 'kyaraben' or 'character bento,' in which people prepare the food in their bento boxes to resemble their favorite characters. It has become a widespread Japanese phenomenon, and there are even national kyaraben contests. Try out your own character ideas!

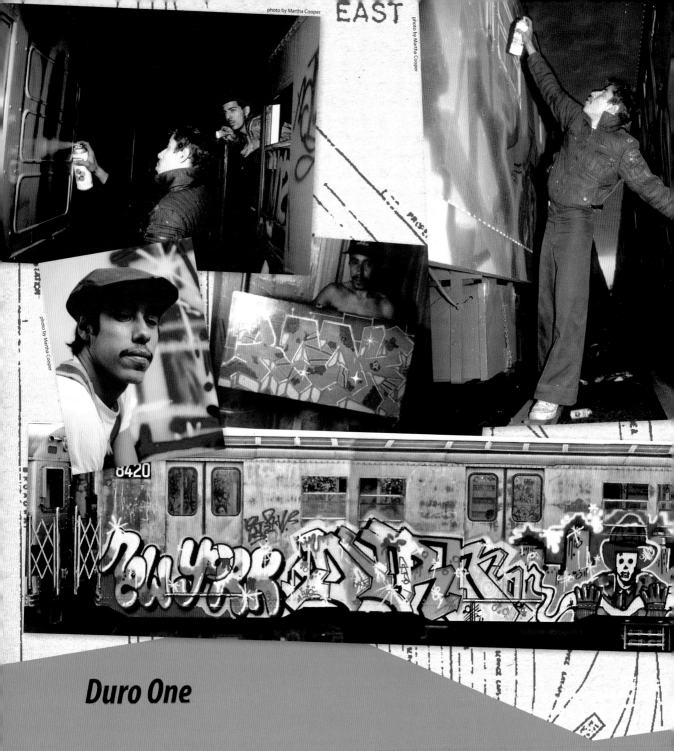

photo by Martha Cooper

EAST

photo by Martha Cooper

photo by Martha Cooper

Duro One

Duro One made his mark as a graffiti writer from the 1970s to the 1980s. He is one of the outstanding artists in the history of subway writing. He began painting graffiti with the name Track 111 in late 1971 in East New York. Besides the name Duro One, over the years he used the names Sono One, Raul, Kino, Wink, Dirty 130 and Lean; and was a member of various crews including CIA, TOP, News Breakers, Rocstars and RTW. He was one of the most active writers in the late 70s and painted numerous top to bottom whole cars as one of the most productive members of CIA. In 1980 Dondi appointed Duro to be Vice President of CIA.

In 1981 Duro was the first graffiti artist to be interviewed for a TV show (Channel 2), along with Crash and Lady Pink. Duro also had a scene in Tony Silver's and Henry Chalfant's documentary 'Style Wars,' and his work was featured in Cooper's and Chalfant's legendary book 'Subway Art.' His picture was the first one to be used on the cover of a substantial graffiti book, 'Getting Up' by Craig Castleman.

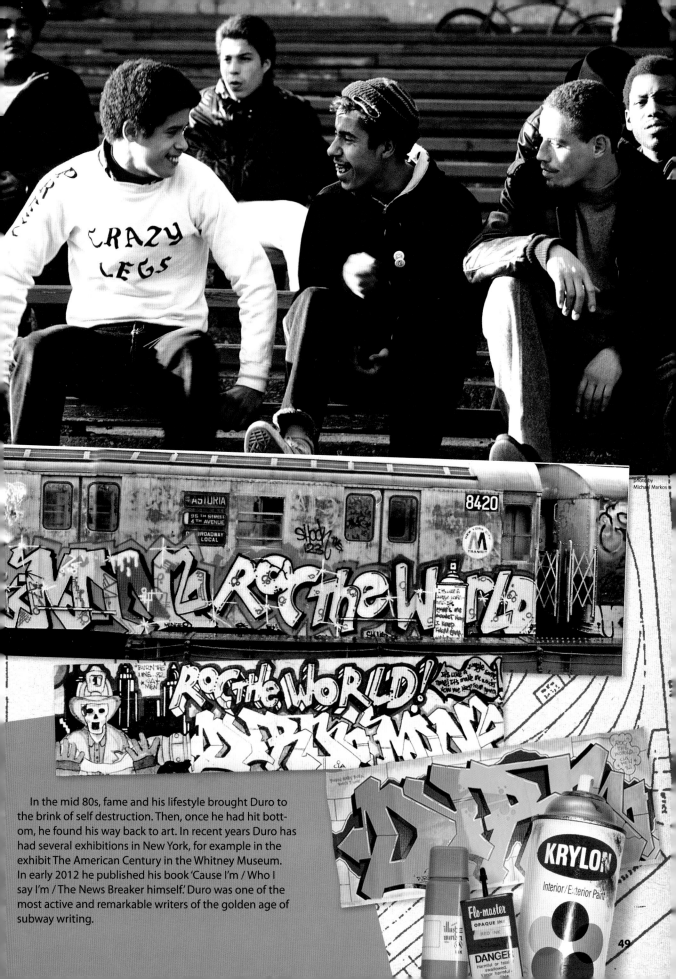

photo by
Michael Markos

In the mid 80s, fame and his lifestyle brought Duro to the brink of self destruction. Then, once he had hit bottom, he found his way back to art. In recent years Duro has had several exhibitions in New York, for example in the exhibit The American Century in the Whitney Museum. In early 2012 he published his book 'Cause I'm / Who I say I'm / The News Breaker himself.' Duro was one of the most active and remarkable writers of the golden age of subway writing.

Pasteles

Cooking supplies:

- food processor
- banana leaves (substitute parchment paper) about 25 x 13 cm *(10 in x 5 in)*
- butcher's twine
- parchment paper

When I was a kid we didn't have food processors, so we used the fine side of a grater, el guayo, to make the masa.

Pork filling:

- about 1½ kg *(3½ lbs)* pork shoulder
- 3½ Tbsp of recaito (see recipe page 110)
- 240ml *(8 oz / 1 can)* tomato sauce
- 590ml *(2½ cups)* water
- 2 tsp salt
- ¼ tsp black pepper
- 1 pack of sazón with achiote (annato) (for homemade sazón see recipe page 110)

Cut the pork into small pieces. Place all of the pork and the rest of the filling ingredients into a large pot. Bring the mixture to a boil, reduce the heat and let simmer for 45 minutes. Using a slotted spoon or colander, separate the meat from the sauce. Place the meat in an uncovered container so it will cool faster, and set aside 235ml (1 cup) of the filling sauce for the masa.

Pasteles is part of being Puerto Rican. Not having pasteles on our table during Christmas would be like not having Santa Claus or the three kings bring gifts. It's a lot of work but it's worth it.

They are made with dough made from starchy roots and other vegetables. The pastel stuffing can be made from pork, poultry and seafood. For this recipe we will use the traditional pork stuffing.

Masa (dough):

- 10 very green bananas
- 2 medium size Idaho potatoes
- 6 Tbsp achiote
- 5 Tbsp salt (to taste)
- 235ml (1 cup) pork stuffing sauce

Peel and cut all of the vegetables into small pieces and place them into a large pot with heavily salted cold water. Once everything has been cut, have a large pot ready to put the processed masa into. Drain the bananas and potatoes and fill a food processor halfway with the pieces. Pour a little of the filling sauce into the processor, cover and process on high until the mixture has the consistency of oatmeal, add more pieces through the slot until all of the pieces have been processed. Pour the processed masa into a large pot and add the salt, achiote and the remaining sauce. Mix well and taste to check if the masa needs more salt.

Pasteles

- To cut the butchers twine into pieces of equal lengths, I grab the tip of the twine and spin it from my thumb to my elbow about 24 times. Next, I cut the twine on my thumb and then I cut these pieces in half so that they're all about 50 cm (19 in) long.

- To wrap the pasteles, place a piece of parchment paper on the table and place one of the banana leaves in the middle. Put a little less than 1 Tbsp of achiote in the middle of the banana leaf, and spread it out using a circular motion. Place about 120g (½ cup) of the masa in the middle of the banana leaf and spread it out using a circular motion. Drop 2 Tbsp of filling onto the masa. Lift the top and bottom edges of the parchment paper until they meet evenly. Fold or roll down the edges to form a horizontal seam. Fold the ends of the parchment paper down until it meets the pastel and then fold in the sides. Place a piece of the twine on the table and flip the wrapped pastel over so that it's resting upside down on the twine. Tie with the butcher's twine to form packets and repeat.

- Steam the pasteles for 45 minutes over salt water. Unwrap the pasteles before serving.

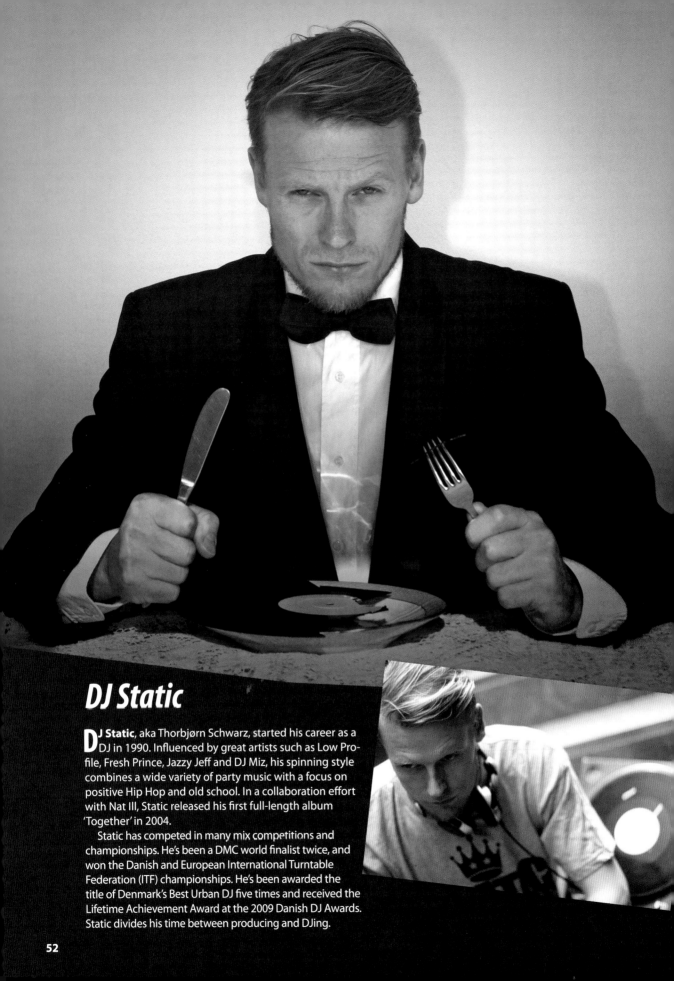

DJ Static

DJ **Static**, aka Thorbjørn Schwarz, started his career as a DJ in 1990. Influenced by great artists such as Low Profile, Fresh Prince, Jazzy Jeff and DJ Miz, his spinning style combines a wide variety of party music with a focus on positive Hip Hop and old school. In a collaboration effort with Nat III, Static released his first full-length album 'Together' in 2004.

Static has competed in many mix competitions and championships. He's been a DMC world finalist twice, and won the Danish and European International Turntable Federation (ITF) championships. He's been awarded the title of Denmark's Best Urban DJ five times and received the Lifetime Achievement Award at the 2009 Danish DJ Awards. Static divides his time between producing and DJing.

Static's Potato Soup

Ingredients:

- 750g *(about 1½ lbs)* potatoes
- 3 carrots
- 1 leek
- 300g *(10 oz)* bacon
- 3 slices of cooked ham
- 1L *(35fl oz)* vegetable broth
- 1 Tbsp clarified butter
- 125g *(½ cup)* cream
- 1 Tbsp crème fraiche
- salt, pepper
- 2 tsp marjoram
- 2 bay leaves
- 1 bunch of fresh chives
- fresh herbs for seasoning and decorating

- Cut the bacon into small cubes. Peel and dice the potatoes and carrots. Wash and slice the leek.
- Heat the butter in a pan and fry the bacon. Set it aside and sauté the vegetables and potatoes, seasoning them with salt, pepper, marjoram and bay leaves. Pour the broth and bacon into the pan and let simmer for about 20 minutes covered.
- Remove the bay leaves and stir in the cream. Take out half of the vegetables with a slotted spoon. Puree the rest of the vegetables with an immersion blender. Place the diced vegetables back in the soup, taste and adjust the seasoning if necessary.
- Slice the ham into quarters and finely chop the chives.
- Put the soup in bowls, then add the ham and a spoonful of crème fraiche to each one. Sprinkle the finely chopped chives over it and enjoy.

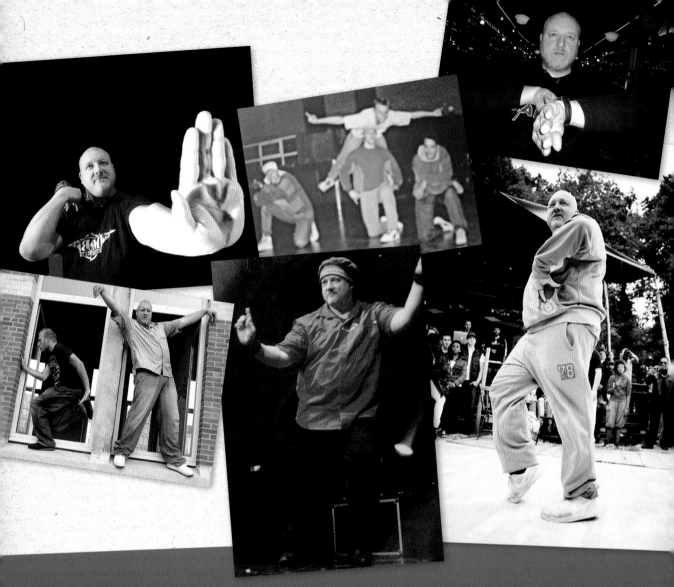

Gerrit "Wise" Wellens

Motivated by a love of dance, music, culture and Pak Mee Pai, Wise was a longtime member of Les Anciens, a poppin' and lockin' crew, with Mike "Chain Reaction" Alvarez (Bang Gang Dance comp, 2step dance company). It all started when Wise met Nii in a local club called Funk You. After discovering that they had the same passion for music and dancing, they joined forces and started a group called Fresh Two, in which Wise performed for the first time.

Eager to learn and improve, Fresh Two used every available opportunity to work on their art. Their dedication allowed them to met Julio "Bader" Calderone, who came to Europe to teach the art of b-boying and founded the Antwerp Break Masters, the Belgian chapter of the Bronx Break Masters. After Bader's return to Planet Rock he placed Nii and Wise in charge of the group. A few

years later, they opened their own dance school, holding numerous performances and getting their art out on the streets. After the Antwerp Break Masters, Wise did solo performances and was often consulted to dance with other crews. Wise met Taco in 1999, who gave him an extra impulse on the poppin' side through which the idea grew for Les Anciens.

A solo artist with b-boy skills who specializes in poppin', Wise still organizes small events and supports the local and international scene. He was one of the founders of the Belgian Hip Hop alliance, an entertainment, production and booking organization focused on the Hip Hop culture. It was one of the first organizations back in the 80s to offer a platform for the local scene; the BHHA organized the first Hip Hop parties, workshops and published their own magazine 'DEF' (definitely exciting and fresh).

Turkey Stew with Kriek
(Belgian cherry beer)

Ingredients:

- 1kg *(about 2 lbs)* turkey filet, cut into small pieces
- 1 green pepper
- 1 red pepper
- 1 yellow pepper
- 1 big red onion
- 2 slices of honey cake (you can also use white bread) covered with mustard
- pepper and salt
- olive oil
- butter
- chicken bouillon (1 cube or to taste)
- white flour
- 2 bottles of 33cl *(12 oz)* cherry beer (recommended: Lindemans Kriek)

- Mix the flour with pepper and salt, dip the turkey pieces in the flour mixture until they are completely covered.
- Quarter the peppers and remove the seeds, then chop the peppers and onion.
- Fry the turkey in a pan with oil until it is brown on each side. Then set the turkey aside.
- Put all the vegetables in the same pan and cook for 5 minutes, or until the onion starts to become glazed and brown.
- Mix the turkey and the vegetables in a pot.
- Put the cake (or bread) slices on top.
- Add the chicken bouillon and the beer, and cook on simmer for about 90 minutes, stirring occasionally.
- Serve with oven baked potatoes or rice (delicious with coconut rice—add coconut milk to the rice when it boils) and corn on the cob. Serves 5–6 people.

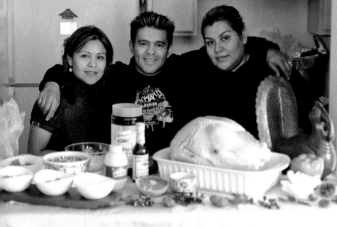

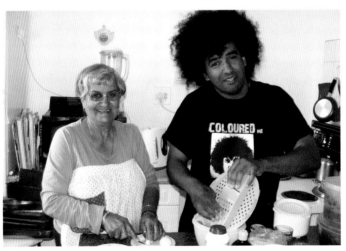

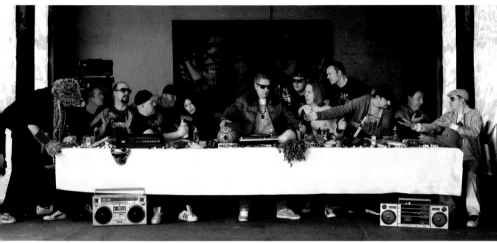

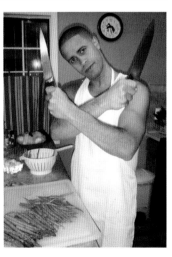
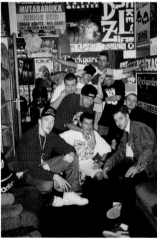
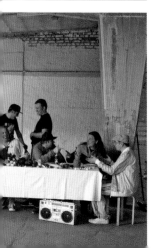

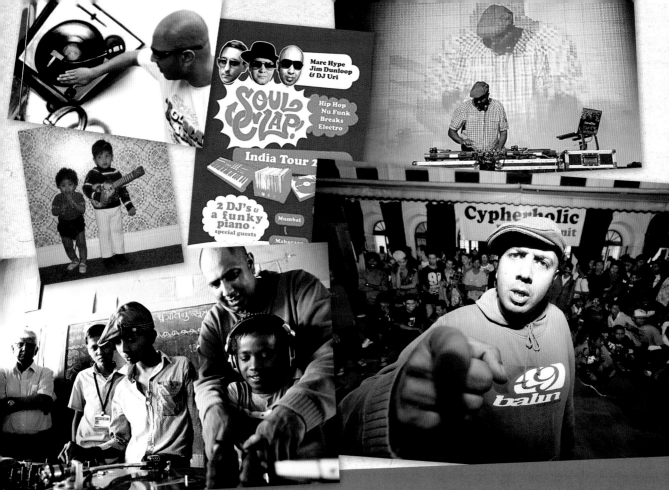

DJ Uri

DJ Uri was born in east London in 1974 and started his over three decades long career as a DJ in 1982. He was highly influenced by his exposure to the underground music scene in his youth, 'Street Sounds Compilations' and breakdancing.

After receiving his first turntables at age 13, he started to DJ for the Hip Hop crew The Uptown Posse and within the next two years he was performing in front of crowds playing Hip Hop, disco, funk and soul. Uri continues to be an active DJ with the same desire to drop the freshest and funkiest music at his regular gigs across the UK, Europe and India.

With 17 years of experience rocking the Indian club circuit, Uri is the face of the b-boy DJs in India. He takes pride in guiding the rapidly growing Hip Hop scene across the country and has been teaching local DJs how to lay down funky tracks there since 1995. After deciding to make Mumbai his permanent base in 2009, he started funk and old skool Hip Hop club nights like Ghettoblaster and Recycled, as well as nurturing the thriving dubstep and drum & bass scene with his monthly bass night Wobble! & Evolution: The History of Drum & Bass, a night showcasing the progression of DnB.

The vastness of his music collection and knowledge as a DJ are a positive influence on Hip Hop culture. He lives and breathes the essence of old school and continues his pledge to only play on vinyl decks, staying loyal to the art of Turntablism.

Uri also dedicates his time to passing on his skills and personal experiences to the next generation of scratch DJs. As a tutor for Access to Music, Rock School and 2Funky, Uri is passionate about music education. In February 2006 he opened his own DJ academy, Start from Scratch, which offers DJing, music production and lyric writing workshops across the UK. He is also a part of the Tiny Drops Hip Hop community project in Mumbai and Delhi, and was their official spokesperson at the Pop-komm Music Seminar in Berlin in 2011. His recent project in Gujarat alongside Mandeep Sethi (SlumGods / Zulu Nation) and Roc Fresh Crew (Mumbai) has opened up a new avenue for Hip Hop culture to spread deeper into rural India.

In the last year Uri has worked in conjunction with Akim Walta on the German India project. An exchange program between two similar music events, Soulclap! (Berlin) and Ghettoblaster (India), brought Uri to Germany to participate in Berlin Music Week and DJ Marc Hype from Berlin to tour in India.

Jungle Spice Lamb Curry

A fusion of my Indian & East African roots.

Ingredients:

- 400g *(14 oz)* boneless lamb
- 1 star anise
- 1 cinnamon stick
- 5 cloves
- 1 cardamom pod
- 2 bay leaves
- 3 onions
- 3 medium sized green chilis
- 4 large garlic cloves
- 3.5 cm² *(1½ in²)* fresh ginger root
- 2 Tbsp cumin powder
- 2 Tbsp coriander powder
- ½ Tbsp red chili powder
- ¾ Tbsp turmeric powder
- ½ Tbsp garam masala powder
- ½ Tbsp salt
- 2 medium size potatoes
- 80ml *(3fl oz)* sunflower oil
- 200g *(6½fl oz)* tomato passata (tomato puree)
- 500ml *(17fl oz)* water
- Handful of fresh coriander leaves

- Cube the lamb and finely chop the onions, chilis, garlic and ginger. Peel and quarter the potatoes. Chop the coriander leaves.
- Pour 60ml of the oil into a large, heated non-stick pot. Fry the star anise, cinnamon stick, cloves, cardamom pod and bay leaves on medium high heat until you hear a popping sound. Add the onions, stir and cover with a lid. Let the onions cook on medium high heat for about 20 minutes, stirring occasionally to prevent burning.
- Once the onions have a deep golden brown color, add the chilis, garlic, ginger, cumin, coriander, chili, turmeric, garam masala and salt to the pot.

- Mix all the spices together and cook with the lid on for 1 minute. At this point the mixture will be dry, so add the remaining 20ml of oil to loosen the mixture. It is important for the spices to fry, so check that there's enough oil in the pot.
- Add the tomato passata (puree), stir well and put the lid back on the pot. Cook for 2 more minutes. Once the oil is rises to the top of the tomato mixture add the lamb and potatoes. Stir well and cover all the pieces of lamb and potatoes with the sauce.
- Put the lid back on the pot and cook everything for 20 minutes on medium heat. Check frequently to make sure the lamb is not sticking to the pot. After 20 minutes, pour 300ml *(10fl oz)* of boiling water into the pot and stir well. Put the lid back on the pot and simmer for another 20 minutes.
- Turn off the heat and add the fresh coriander leaves. Let the curry rest for 10 minutes. Serve yourself a large portion of the lamb curry with some steamed basmati rice and enjoy my grandfather's unique recipe, which he crafted in Uganda, after he moved there from India in the 1960s. Serves 4 people.

TimSki

At the age of ten, young TimSki made his mark by scribbling his name in his neighborhood, along with the names of his Surinam, Turkish, Moroccan, Italian, Moluccan and Dutch friends. Inspired by the punk graffiti movement, the political activism of his parents and the roots reggae of the late 70s and early 80s, the foundation for TimSki's career in Hip Hop culture was laid early. 1982 was the same year b-boying arrived in his hometown, Haaksbergen. Always a street kid at heart, TimSki hung around with the older juvenile delinquents from Amsterdam and was soon infected with the street crime virus himself. The rap track 'The Message' by Grandmaster Flash and the Furious Five and 'Hey You,' released by the Rock Steady Crew, really caught his attention. It all came together for him and his friends: their very own movement, called Hip Hop.

Early visits to Amsterdam showed him that graffiti was changing from punk tags to pieces. B-boying died out in Holland in the mid 80s and TimSki started to focus on graffiti writing. Graffiti was harder, tougher and more exciting: just what the thrill-seeker in him was after. He co-founded the Stomping All Toyz crew with a bunch of local youngsters who were all about graffiti, DJing, MCing, throwing parties and juvenile crime. They soon became notorious in the Hip Hop scene, which was starting to turn violent.

However, TimSki has always looked at Hip Hop as something that keeps him on the right track.

"From the first moment I came in touch with Hip Hop back in '82 I was attracted by the fact that it was a culture of several elements. The idea of repressed youngsters speaking up against the system, bringing a positive message to their own community and using their creativity to do so appealed to me. I knew Hip Hop was not just a music style, it was about reality, our reality, and I knew if we could all stick together Hip Hop would open doors. My passion for Hip Hop, especially graffiti, allowed me travel throughout the country and to foreign jams, meeting

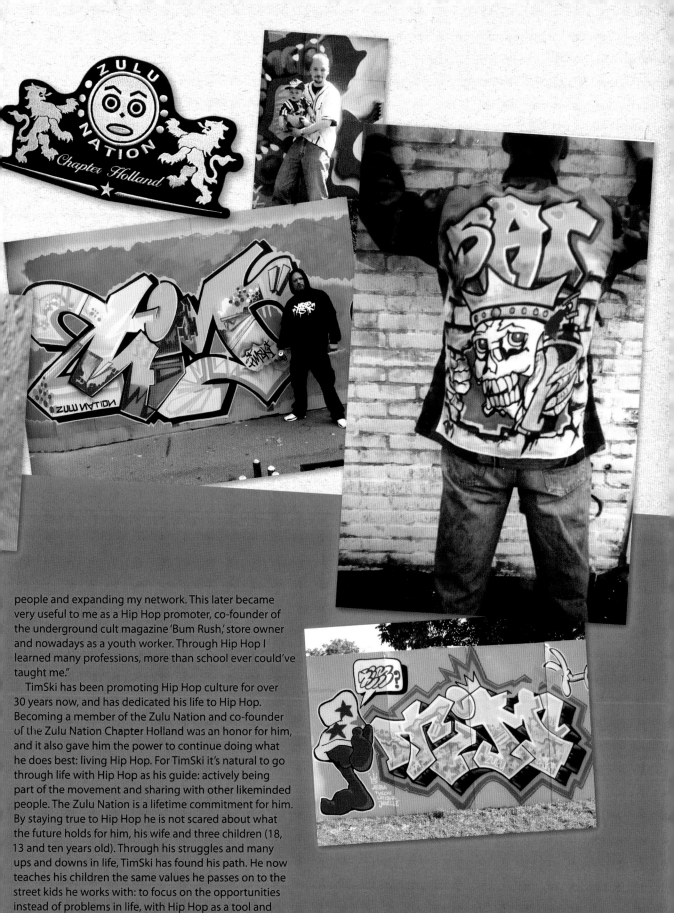

people and expanding my network. This later became very useful to me as a Hip Hop promoter, co-founder of the underground cult magazine 'Bum Rush,' store owner and nowadays as a youth worker. Through Hip Hop I learned many professions, more than school ever could've taught me."

TimSki has been promoting Hip Hop culture for over 30 years now, and has dedicated his life to Hip Hop. Becoming a member of the Zulu Nation and co-founder of the Zulu Nation Chapter Holland was an honor for him, and it also gave him the power to continue doing what he does best: living Hip Hop. For TimSki it's natural to go through life with Hip Hop as his guide: actively being part of the movement and sharing with other likeminded people. The Zulu Nation is a lifetime commitment for him. By staying true to Hip Hop he is not scared about what the future holds for him, his wife and three children (18, 13 and ten years old). Through his struggles and many ups and downs in life, TimSki has found his path. He now teaches his children the same values he passes on to the street kids he works with: to focus on the opportunities instead of problems in life, with Hip Hop as a tool and Zulu Nation as the resource.

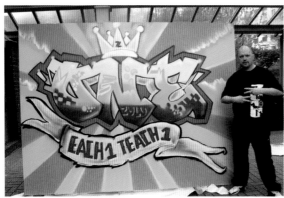

TimSki's Easy Does It Curry

*Typical Dutch food is absolutely not my favorite.
I prefer Asian food. I don't know the name of
this meal, I just call it Easy does it.*

Ingredients:

- 500g *(18 oz)* celery
- sweet (bell) peppers: green, yellow, red
- 2 Tbsp sunflower oil
- 285g *(2 cups)* cashews
- 400g *(14 oz)* chicken filet (or tofu)
- 1 tsp oyster sauce
- salt, pepper, ginger, turmeric, cilantro
- white rice
- coconut milk

- Chop the chicken filet (or tofu) into small pieces. Mix the salt, pepper, ginger, turmeric and cilantro in a bowl, then add the chicken (or tofu) to the mixture and let it marinate.
- Chop the celery and sweet peppers. Cook the rice and add the coconut milk when it boils. In the meantime, heat the oil in a pan, add the chicken (or tofu) and stir it. Add the sweet peppers and celery, and cook it for about 10 minutes. Add the cashews and then the oyster sauce. Serve it on a dish with cassava, peanuts and cucumber slices…
- Eet smakelijk! (Enjoy)

SeeN

Seen is an OG popper and graffiti writer from Osaka, Japan. He was born in 1966 and was raised by Christian adoptive parents. Growing up, he struggled to express himself and find his true identity. He initially found his voice through graffiti writing and soon became a popular graffiti artist. He has won multiple awards, including the Best Custom Paint Award for Low Rider Muralists in Japan.

In 1979, Seen discovered his passion for R&B and funk music. He started digging in crates of vinyls to look for treasures, and now he has over 5,000 records in his collection. Around 1982, he was inspired by the "what you see is what you get" vibe of 80s pop culture, and he found his calling in the iconic street culture pasttime of the era: breaking. After 1983, street culture gradually started to be imported all over Japan.

The legendary Navio Mae Poppers were founded on the pedestrian street mall between 1983 and 1985, and they would perform everything from boogaloo to breaking in front of the Navio Mall in Osaka. In 1984, Seen started to establish the dance style he is known for today along with Poppin Pete (who went by "PP" back in the days), Skeeter Rabbit (RIP), the Electric Boogaloos and Donald D and the Boo-Yaa T.R.I.B.E. Donald was an especially great influence on him.

In Japan, this street culture began stepping into the disco and club scenes. In 1986, three of his HS buddies and Chiho (who is now his lovely wife!) founded a crew called YO-BBO. In the 1990s, they became YO-BBO Bad Family.

They are the one and only crew to drop a show which combines break, pop, lock, Hip Hop and rap all together. At their high point they had more than 30 members from all over Japan.

His cred as a Master Popper led him to become a popular pop teacher in Osaka, Japan and Seoul, South Korea. He was one of the gold dancers on the 'Super Chample' TV show and a popular judge for the Old School Night, UK Championship Japan and the Free Style Session Japan, among others.

Osaka (Japanese) Tacos

Teriyaki Chicken:

- 250g *(9 oz)* chicken breast
- teriyaki sauce

Cut chicken into strips. Grill until brown on both sides. Give the chicken one final baste of the teriyaki sauce.

Shrimp Tempura:

- 180g *(¾ cup)* flour
- ½ tsp baking powder
- ¼ tsp salt
- 1 egg yolk
- 200ml *(7fl oz)* ice water

Sift flour, baking powder and salt into a bowl. Beat the egg yolk gently and add iced water and 2 ice cubes. It's important to keep the batter icy cold at all times. The crispiness of tempura comes from the temperature difference between oil and batter. Combine the egg and flour mixtures. Dip the shrimp in batter several times, making sure shrimp is completely covered by the batter, and deep fry until golden brown.

Fill tortillas with all the toppings and serve warm.

Gobo Shoyu-Mayo:

- 2 burdock roots
- 2 carrots
- 4 Tbsp Japanese mayonnaise
- 1 Tbsp soy sauce

Peel the burdock and carrots and boil for about 3–5 minutes. Cut into 5 cm *(¼ in)* pieces and then slice finely. Mix the soy sauce and mayonnaise in a bowl and then mix in the carrots and burdock.

Edamame:

- 450g *(1 lb)* fresh edamame in pods, frozen edamame in pods or shelled edamame beans
- salt (The desirable amount of salt varies depending on the amount of water to boil edamame.)

Cut off the stem end of each pod. Wash edamame well and put in a bowl. Add a pinch of salt and mix it with the edamame. Boil lots of water in a large pot. Add about 2 Tbsp of salt in the boiling water. Put edamame in the boiling water and boil for 3 to 4 minutes, or until soft. Drain edamame in a colander. Taste one edamame and if it's not salty enough, sprinkle more salt over boiled edamame. Remove edamame from pods (only the beans are edible).

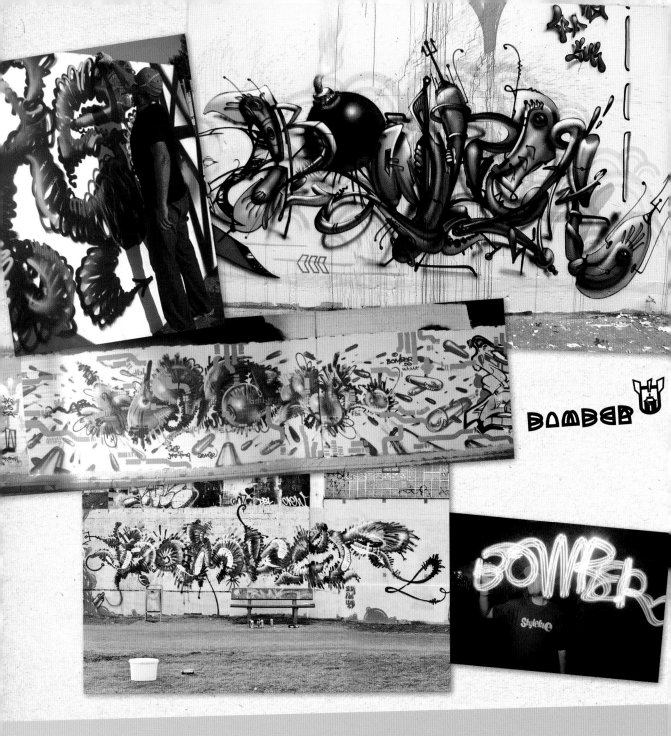

Bomber

Bomber, aka Helge Steinmann, is a one-man graphic communication designer and free artist.

His creative projects started with urban art, such as intense style writing (graffiti) in the middle of the 80s, followed by graphic and communication design and arts in 1990. He is a self-taught artist in style writing and urban art. Bomber's designs draw on his experience working on the streets of cities throughout Europe, education in the field of communication design at the University of Applied Sciences in Darmstadt, Germany, teaching others graffiti disciplines, starting his own design office and advertising agency, and working on commissioned projects. His main creative tasks include design work in painting, print, web, animation and illustration. This work often results in interesting exhibitions and in collaborations with other artists and designers. The name 'Bomber' stems from Steinmann's early style writing and graffiti years, being both a pseudonym for the artist, and the name of a famous German graffiti legend.

Coleslaw à la Bomber

- Remove wilted leaves from the outside of the cabbage, wash and remove the stem.
- Then slice the cabbage into small strips. Put the strips in a bowl, add salt and mix well with your hands.
- If possible, let it sit overnight for a more intense taste.
- Dice the onions and mix with the cabbage. Season with herb salt, brown sugar, freshly ground pepper, white wine vinegar, balsamic vinegar and sunflower oil.
- Add Worchester sauce, Tabasco and Maggi seasoning. Chives, parsley, dill and borage (starflower leaves) will also give the salad an excellent taste.

Ingredients:

- one head of white cabbage (750–1000g / 25–35 oz)
- 1 onion or 1–3 spring onions
- pepper
- salt
- 4–5 dashes of Worchester sauce
- 2 dashes of Tabasco sauce
- 3 dashes of Maggi seasoning
- balsamic vinegar
- 3 tsp (15ml) white wine vinegar
- 3 tsp (15ml) sunflower oil (if desired, olive, pumpkin seed or thistle oil can be used)
- a little water
- a little brown sugar
- if desired, add grated carrots and/or bacon

Rosy One

In **1989**, at age twelve, Rosy One fell in love with the Hip Hop culture through the music. After traveling with her family to Paris and Berlin, she started to draw graffiti and began tagging 'Mystery' in the streets. In 1990 she started to do graffiti with the names 'Danger,' 'Scrag' and 'Mok la Rock.' She hit trains with a mad obsession all over the world, including the New York subway. In 1996 she was arrested by the police while she was taking a photo of a painted train. The police tapped her phone for three months and she spent two weeks in jail. Her case started a long odyssey through different levels of jurisdiction, which resulted in a bad financial situation, four months of prison and probation. After 1996 she had to reorient herself and she found a new name: Rosy One.

Over the years she has developed incredible style skills and unique, world famous characters. She has successfully constructed a perfect marriage between the old and the new. She is inspired by the so-called "Golden Era" of 80s Hip Hop culture in different ways and collects vinyl, tapes, ghetto blasters, sneakers, clothes and magazines from that period of time. Rosy One is a Hip Hop all-rounder. She used to breakdance and DJ under the name Mok la Rock, under which she released three mix tapes: 'Other Side of Town,' 'Boys and Girls' and 'Dance with the Devil.' She is also the person behind the Dopepose project, a website with a growing collection of photos of people doing dope poses. In 2011 she released the dope pose book: 'Cause We Got Style!: Hip Hop posing photos from the 80s and early 90s,' with the Swedish publisher Dokument Press.

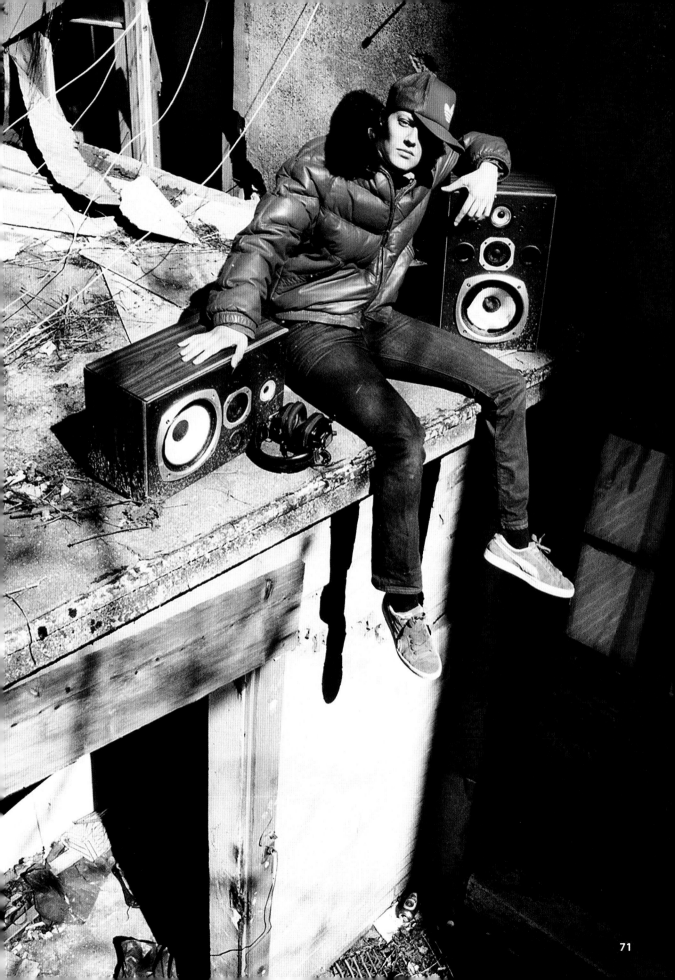

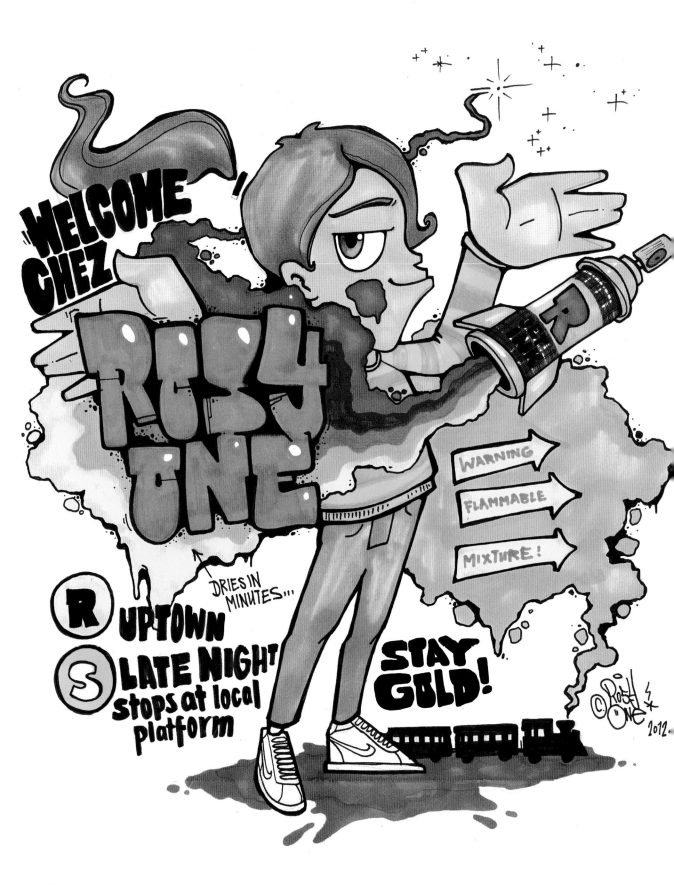

Alpine macaroni
(Alpenmagronen)

"Alplenmagronen" is a typical meal in Switzerland, where I'm from. My grandmother used to cook it for me and today I often cook it for my kids because it is very easy to do.

Ingredients:

- 400g *(14 oz)* elbow macaroni
- 250g *(9 oz)* potatoes
- 2 large onions
- 2 Tbsp clarified butter
- 3 tsp *(15ml)* cream or milk
- 300g *(10½ oz)* shredded cheese (Swiss mountain cheese "sprinz")
- salt, pepper
- applesauce

- Peel and cube the potatoes, then cook for approx. 15 minutes and drain.
- At the same time, cook the noodles in a different pot until tender, then drain. While the noodles and potatoes are cooking, cut the onions into rings and brown them in a pan with the clarified butter.
- Cook the cream (or milk) on the stove and add ⅓ of the cheese. Stir the mixture thoroughly.
- Mix the noodles and potatoes with another third of the cheese, season with salt and pepper and put it in a saucepan.
- Pour the cheese sauce on top. Then sprinkle with the remaining cheese and place the sautéed onions on top.
- Cover the pan and warm it up on the stove (or in the oven) until the cheese melts. Serve with applesauce.

73

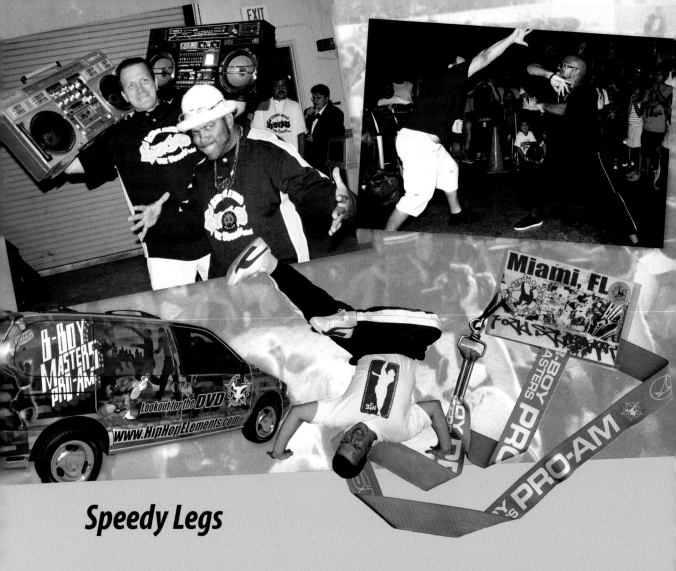

Speedy Legs

B-boy **Speedy Legs**, born Ricardo Fernandez Jr., in Havana, Cuba, has been the driving force of the Miami b-boy scene since 1981. In 1986, he came up with the name 'Hip Hop Elements' for a live performance piece. In 1992, he launched a clothing line and started getting involved with community Hip Hop events. Then, in 1996, Speedy Legs founded the B-boy Masters Pro-Am with Zulu Gremlin. It was the first and only annual battle in the United States at the time.

Speedy has over 30 years of experience as a professional dancer and choreographer. He has performed in films, the off-Broadway show 'Jam On The Groove,' and countless concerts alongside great artists such as: Run DMC, Afrika Bambaataa, Kool Herc, Wu-Tang Clan, Mos-Def, Tony Touch, Beanie Man and Buju Banton. In 2003, he was hired by Wyclef to perform at the opening of the Source Awards Live on BET. In 2005, Speedy Legs choreographed a theater show entitled Scratch & Burn for the Miami Light Project, an organization in which he has been active since 2002. During his long career, Speedy has made numerous appearances on TV stations from ESPN to Telemundo; in newspapers including 'The New York Times,' 'The Washington Post' and 'Miami Herald;' as well as in magazines such as 'Stress,' 'Source,' 'Rap Pages' and 'Blaze Magazine.'

While he mostly grew up in Miami, Speedy Legs spent the latter half of the 1980s and the early 1990s living in New York—pursuing his dreams and battling the creators of Hip Hop dancing. It was during this time that he grew close to and won the respect of organizations like Zulu Nation and the members of historical b-boy crews. When the scene in New York started dying out, Speedy Legs returned to Florida and started Pro-Am. He put Miami on the map by inspiring a whole new generation of b-boy superstars in crews like Street Masters, Ground Zero, Flipside Kings, Skill Methodz, Illmatic Flow, Unique Styles, Mind 180, Future Force, Raw Meat and many more. His website HipHopElements.com was also one of the first Hip Hop dance websites on the net.

Speedy has constantly worked as an entertainer and is deeply involved with the community. He has spent 15+ years teaching dance classes to underprivileged children and young adults at centers such as the Boys & Girls Club and various Miami recreation centers. Local press and TV stations have done many stories about his efforts to keep kids off the streets and involved in positive recreational activities. Speedy Legs is a pioneer of the art form and is internationally recognized as the godfather of the Florida Hip Hop dance scene.

The Land and the Sea Delight

Ingredients:

- 1 Tbsp dried thyme
- 1 Tbsp onion powder
- 1½ Tbsp marjoram
- 2 Tbsp garlic powder
- 1 Tbsp black pepper
- 1 Tbsp cayenne pepper
- 1½ Tbsp salt
- 2 Tbsp rose (pink) pepper
- 3 fresh garlic cloves, pressed
- 1 red and 1 yellow chili
- 1 stalk of broccoli
- olive oil
- 200g *(7 oz)* chicken breast
- 3 Norway lobster (aka scampi)
- 4–5 potatoes
- 1 red onion
- flour
- 75ml *(2½ fl oz)* water
- 500ml *(about 20fl oz)* vegetable oil (for frying)

- Mix the dried herbs in a bowl and set aside.
- Cut the broccoli into small florets and rinse. Chop the chilis and heat some olive oil in a frying pan. Add the fresh garlic (1½ cloves), chopped chilis and broccoli. Sauté for about 5 minutes. Then, add the water, salt (to taste) and let it cook for approx. 8–10 minutes. The broccoli should remain somewhat firm.
- Sauté the Norway lobster in olive oil with the remaining garlic and a few dashes of the dried herb mixture in a cast iron pan.
- Quarter and boil the potatoes until they are cooked but still rather firm, and drain. Peel and finely chop the onions. Sauté the onions with the cooked potatoes in a pan with olive oil, adding salt and pepper to taste.
- Cut the chicken breast into pieces (approx. 4 cm x 4 cm / *1.6 in x 1.6 in*). Combine the flour and the herb mixture and mix it thoroughly. Roll the chicken pieces in the mixture until covered.
- Heat the vegetable oil in a pot and fry the chicken pieces until golden brown.
- Serve everything hot with a sauce of your choice (recommended: garlic sauce).

RickSki

Detlef Rick, aka RickSki, is a pioneering DJ, producer and rapper from Germany. He grew up in a small village near the city of Cologne, where he first became familiar with Hip Hop through TV reports such as 'Breakout' and movies like 'Wild Style' in the early 80s. While Rick started out with b-boying and graffiti, turntable masters like Grand Mixer DST and Grandmaster Flash inspired him to get heavily into DJing. Working as a team with his younger brother Michael, Rick began to create mixes and demo songs with the help of a reel to reel tape machine, a percussion drum computer and a four-track-recorder.

Shortly after they were able to record their first demo, they landed a record deal with the independent label Rhythm Attack Productions in 1989. Under the name LSD (Legally Spread Dope), the two brothers teamed up

with DJ Defcon and MC Ko Lute, who they had met two years earlier at a local club. In the fall of that year, the EP 'Competent' was released and created a big buzz, not only in the emerging German Hip Hop scene, but also in the media. Praised by the press for its innovative production, the title song made it onto Germany's biggest radio station at the time, WDR 1. A full-length album by LSD, 'Watch out for the third rail,' hit the scene in 1991. These recordings featured Maceo Parker and George Clinton. Once again they managed to impress both their Hip Hop peers and the press with an even more advanced and complex, sample-heavy production.

Dissatisfied with their business situation, LSD left Rhythm Attack Productions after one more EP in '91, to establish Germany's very first all-Hip Hop label Blitz Vinyl. Around this time, the original LSD group split into two different crews. Their last recording together was a

song called 'Accompagnato,' featured on the compilation 'Krauts with Attitude.' While all their previous recordings were rapped In English, this was one of the first rap songs released in German.

In the following years, RickSki worked on several groundbreaking recordings on Blitz Vinyl with his own group, as well as the international Hip Hop crews Blitz Mob, Kaos, First Down, CUS, and more. After Blitz Vinyl called it quits in 1996, he continued to work in the music field. RickSki collaborated with artists such as Torch, Die Firma, Toni L, JuJu (Beatnuts), Funkmaster Ozone, Fader Gladiator, Cora E, Def Benski and Promoe, as well as with music legends like Pee Wee Ellis, Tony Cook, Fred Wesley and many more. In 2008, the album 'Watch out for the third rail' had become such a milestone in German Hip Hop that it was re-released and once again highly praised. RickSki continues to DJ and perform throughout Germany, Switzerland, Austria and the rest of Europe. As an audio engineer, he also runs a recording studio and production company in his hometown, where, in addition to his own music, he also creates sound designs for commercials and surround sound projects.

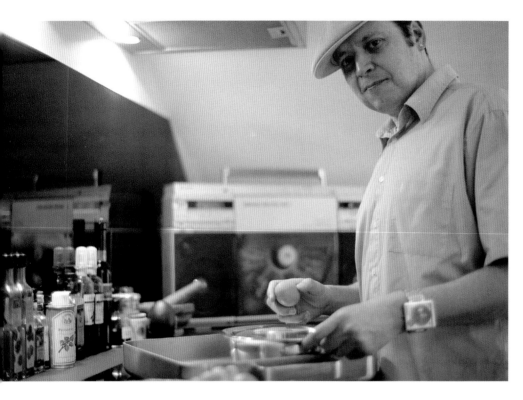

As a fan of a wide variety of international fare, it's impossible for me to name my favorite main dish. However, when it comes to desserts, the choice is easy. My absolute favorite dessert is the Italian classic, tiramisu. Since my family and friends also like this dish, I'm usually responsible for preparing the dessert for our gatherings. In order to keep things interesting, I'm always experimenting with new versions of the classic recipe. Here is my tiramisu recipe with an Oriental twist.

Oriental Tiramisu

Ingredients:

- 5 **tablespoons of very finely ground espresso**
- 1 tsp of ground cardamom
- rosewater
- ground cinnamon
- 2–3 pinches of ground safran
- 30g *(1 oz)* dried barberries
- 30g *(1 oz)* chopped almonds
- 35g *(1.1 oz)* green, unsalted pistachios
- 100g *(3.5 oz)* lady fingers
- 3 bourbon vanilla beans
- 60g *(2 oz)* powdered sugar
- 4 tsp regular sugar
- 3 fresh eggs
- 250g *(1 cup)* Mascarpone cheese
- 2 large organic oranges
- 1 stalk fresh mint

Barberries
Soak the barberries in rosewater for 3–4 hours. They must be drained well before being added to the dough.

Espresso
Mix together ¼ liter *(½ pint)* of water, espresso, regular sugar and cardamom in a pot and bring to a boil. Then, pour some of the espresso into a bowl and let the rest come to a boil again. Repeat the process until all of the espresso has been poured into the bowl. Let the coffee cool completely. The coffee grounds will sink to the bottom of the bowl.

Almonds
Add the chopped almonds into a pan, roast without oil until golden brown.

Batter

- Separate the eggs and place the yolks and egg whites into separate large bowls. Cut open the vanilla beans lengthwise and scrape the paste into the egg yolks. Add the ground safran. Using a whisk or mixer, beat the egg yolk mixture together with half of the powdered sugar. Slowly add the mascarpone cheese (mixing at low speed) until the batter is uniform.
- Beat the egg whites with the remaining half of the powdered sugar until stiff.
- Carefully fold the egg white mixture into the egg yolk mixture using a flexible spatula. The dough should maintain its light, bubbly consistency.
- Chill the batter for 10–15 minutes in the fridge.

Lady fingers

Quickly dip the lady fingers into the espresso coffee, make sure they absorb some of the coffee, but be careful not to let them get too soft.

Layers

- Arrange a layer of lady fingers in a round (20 cm / 8 in diameter) or rectangular casserole dish (approx. 18 x 18 cm / 7 x 7 in). Pour a layer of batter over the lady fingers until they are completely covered. Sprinkle a thin layer of cinnamon over the batter, then scatter some of the roasted almonds on top. Arrange a second layer of lady fingers on top of the batter and repeat these steps until the dish is full and the last layer of lady fingers is covered with batter. Smooth out the top and sprinkle with cinnamon, decorate with almonds.
- Place in the refrigerator and chill for at least 4 hours.

Just before serving

- Fillet and slice the oranges. (To fillet an orange, use a sharp knife and cut off the top and bottom of the orange. Using downward slices, carefully remove the skin and pith of the orange.)
- Roast pistachios in a pan (without oil) until golden brown. Sprinkle the barberries and pistachios over the tiramisu.
- Decorate each serving of tiramisu with 2–3 slices of orange and a mint leaf.

Bon Appétit!

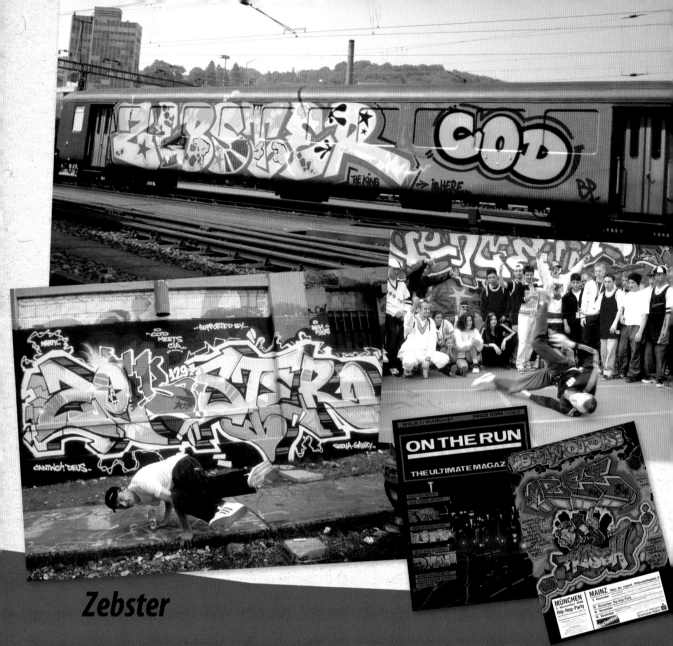

Zebster

Zebster is a graffiti writer, music producer (ZEB.ROC.SKI), self-made historian and organizer of international Hip Hop projects. He began breaking and writing graffiti in the early 80s and is considered to be one of the top European writers of this era.

In 1990, he started the 'On The Run Graffiti Magazine' and in 1992 he founded the Hip Hop label MZEE Records. Later, in 1995, he co-founded From Here To Fame as a Hip Hop publisher of books which showcases the work of graffiti writers and creators of street art. He is also the author of 'Graffiti Art Germany' (1994) and producer of the world-renowned bestseller 'Hip Hop Files' with Martha Cooper. In 2007, he founded the Hip Hop Stützpunkt (Hip Hop base) in Berlin as a headquarters and meeting place for collaborators in his ever-expanding spectrum of urban culture projects.

Zebster is also well known in the global Hip Hop community for his efforts and success in spreading the culture around the world by organizing graffiti jams, events, exhibits, workshops and other projects in Germany and abroad. He is currently coordinating various cultural exchange projects in China and India.

Zebster is inspired by Hip Hop's unique characteristics and rich multicultural elements, which give it the potential to make the world a better place. After all, he has seen and felt the positive effects of the scene on himself and the people around him. Zebster: "Hip Hop gave my life direction. It took me around the world and I was able to meet so many incredibly talented, great personalities, plus I learned a lot of skills that you could never learn in school. Through Hip Hop I was able to learn about and become a part of the worlds of music, media, publishing, culture and politics. There's still a lot for me to discover, and I'm very thankful for that! I believe in respect, equality and creative competition; and I think it's important to 'know your history' and credit the ones who paved the way for you. That's probably the reason why I feel such a responsibility to 'our' culture and feel obliged to give something back."

Zebbie's Mexican Wraps

Mexican wraps:

- 1 onion
- 2 garlic cloves
- 1 green bell pepper
- 400g *(14 oz)* steak filet (beef)
- 5 Tbsp vegetable oil
- herb mixture (see extra recipe on page XX)
- 350ml *(1½ cups)* water
- 8 flour tortillas (soft)
- 1 packet creme fraiche (sour cream)
- 1 cup shredded cheese

Herb mixture (makes 6 Tbsp):

- 1 tsp chili powder
- ¼ tsp garlic powder
- ¼ tsp onion powder
- ¼ tsp red chili flakes (finely ground with a mortar and pestle)
- ¼ tsp dried oregano
- ½ tsp paprika powder
- 1½ tsp cumin
- 1 tsp sea salt
- 1 tsp black pepper

- Peel and chop the onion and garlic. Quarter the bell pepper, remove the seeds and slice into thin strips. Cut the steak into 0.5 cm *(about ¼ in)* strips. Put all the ingredients for the herb mixture in a bowl and mix thoroughly.

- Put the onion, garlic and pepper in a pan with a bit of oil and sauté on low heat for about 5 minutes. Add the steak and sear on high. Next, stir in the herb mixture, add the water and let simmer for about 20 minutes, adding more water as needed. Stir occasionally.

- Place the tortillas on ovenproof plates (1 or more for each person). Put the mixture on one side of the tortilla and close it by folding the other half over the top. Sprinkle it with cheese and place in an oven preheated to 120° C *(250° F)* until the cheese has melted.

- Serve the tortillas with a spoonful of crème fraiche, lettuce, chopped tomatoes and onion. Fresh guacamole, rice and Mexican refried beans also go well with this dish!

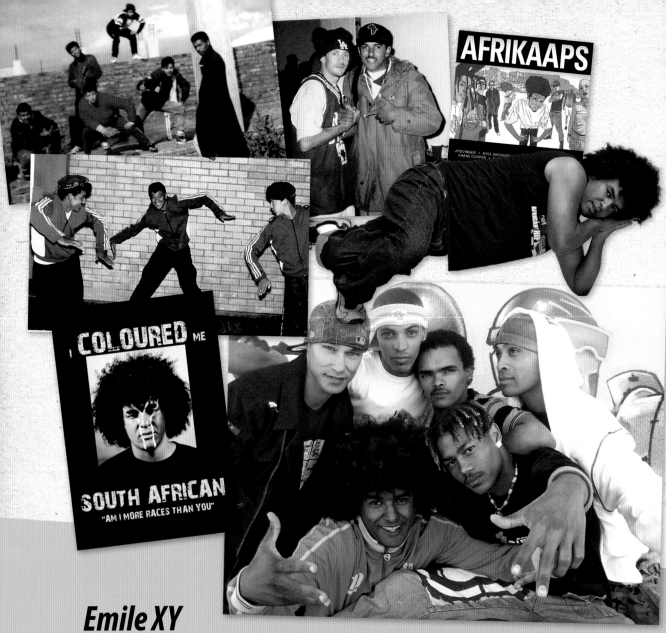

AFRIKAAPS

COLOURED ME
SOUTH AFRICAN
"AM I MORE RACES THAN YOU"

Emile XY

Emile XY started as a b-boy with the Pop Glide Crew in 1982 and formed the legendary South African Hip Hop group Black Noise in 1988. Two years later, they released their first CD, 'Pumpin Loose Da Juice.' In 1993 Emile left his job as a school teacher and created 'Da Juice Hip Hop Magazine.' Inspired by his success, he independently released the second Black Noise CD, 'Rebirth,' and later their third album 'Hip Hop Won't Stop.'

As a member of the Black Noise crew, Emile won third place for South Africa at the world breakdance championship's Battle of the Year in 1997. In the year that followed, Emile brought capoeira to Cape Town and created the Heal the Hood project, a youth outreach program aimed at combating racism and promoting the arts. Shortly thereafter, he handpicked the first South African all-star team for the Battle of the Year in 2000, in which South Africa came in fourth place worldwide.

After the release of Black Noise's fourth CD, the crew toured Sweden, Denmark, Norway, Finland and Holland. Emile has released various solo albums, six CDs with Black Noise (as well as a compilation disc), worked on a collaborative album with Jamayka Poston, released seven Cape Town compilation CDs, and has done CDs for four Cape Town MCs. He's author of the book 'My Hip Hop is African & Proud' and 'RAPSS.' He also helped graffiti artist Mak1 publish a graffiti magazine called 'Stylestudie.'

As an active performer and community activist, Emilie won the Blunt Activist of the Year Award in 2006 and the Community Builder of the Year Award in 2007. In 2008 he compiled a CD called 'Human,' in order to deal with the issue of Afrophobia, so-called xenophobia in South Africa.

Emile has also been a judge at the Red Bull BC One in Johannesburg, and created and hosted annual Hip Hop events like African Battle Cry, African Hip Hop Indaba, Battle of the Year, Freestyle Session South Africa, Up The Rock, Bring Forth the Battle, the Heal the Hood project, R-16 and Shut Up Just Dance.

Bobotie

A spiced meatloaf served with yellow rice. Bobotie comes from from Cape Town, South Africa, which is largely a mixed race community. Bobotie has Indian, European and African influences.

Bobotie:

- 1kg *(about 2 lbs)* lean ground steak or chicken
- 4 slices of bread
- 1 large onion
- 1 large tomato
- 2 large eggs
- 2 tsp mixed herbs (thyme, garlic, parsley and oregano)
- 1 tsp chutney (substitute: marmelade, dash of ketchup and a teaspoon of lemon juice)
- 2 tsp turmeric
- 1 tsp salt
- 2 tsp sugar
- 2 Tbsp raisins
- 2 tsp vegetable oil
- 60ml *(¼ cup)* of milk

- Grate the onion and the tomato.
- Mix all the ingredients except the eggs together in a bowl.
- Place into a greased casserole dish and pat down until flat.
- Pour vegetable oil on top.
- Cook in an oven preheated to 180° C *(360° F)* for 20 minutes.
- Remove from stove.
- Beat eggs in a bowl. When well beaten, mix in 60ml *(¼ cup)* of milk.
- Pour the egg and milk mixture over the Bobotie.
- Place Bobotie back in the oven and cook for another 10 minutes.

Yellow Rice:

- 1 cup of rice (basmati)—well rinsed
- 1 tsp salt
- 1 tsp turmeric
- 2 tsp sugar
- 470ml *(2 cups)* of water

Mix ingredients together in a microwave safe bowl, cover and cook for 15 minutes in a microwave oven. Allow to cool for one hour before serving.

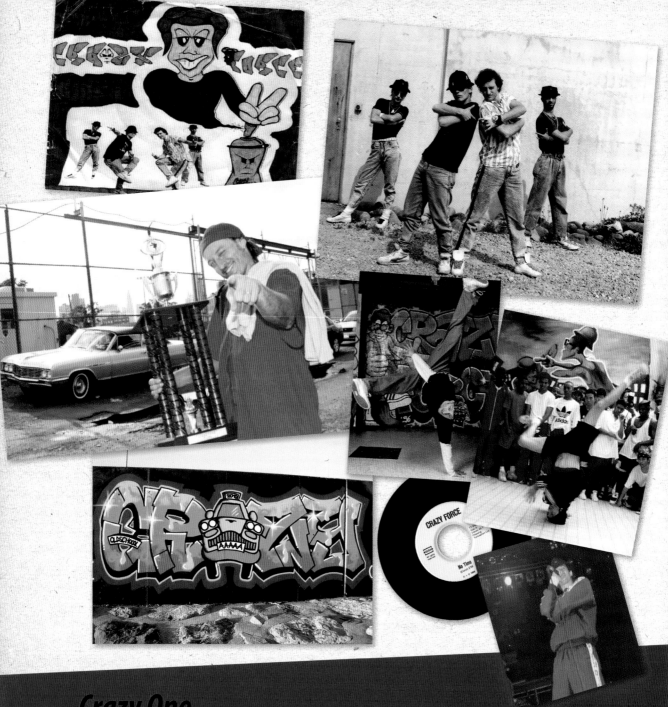

Crazy One

Walter Petrongolo, aka Crazy One, has been a b-boy and Hip Hop activist since 1983. He has participated in breakdance performances, including the European dance show Skydance, and freestyle rap contests internationally.

Since 1987, Crazy One has performed in dance and rap shows, also featuring beatboxing, all over Europe, including Belgium, Germany, England, France, the Netherlands, Italy, Austria, Hungary, Spain and Switzerland. In addition to his many television appearances on German, Swiss and other European stations, Crazy One has participated in various international Hip Hop documentaries, such as 'Styles' and 'The Freshest Kids.' Along with his group, the Crazy Force Crew, he has also recorded numerous singles and albums since 1988. Crazy One has taught a number of different Hip Hop disciplines to people in countries around the world. He's also worked regularly as a judge at competitions and championships all over the world, including the Crew Breaking Contest World Final BOTY.

Crazy One has been an ambassador for preserving the original ideology of the Hip Hop culture from the start. He strives to bring people all across the globe together through the creative potential of this incredible culture.

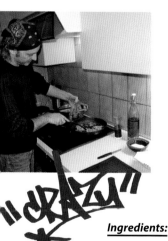

Spaghetti "à la Crazy"

Ingredients:

- 400g *(14 oz)* spaghetti
- approx. 20 prawns
- olive oil
- 1 handful cherry tomatoes
- 1 onion
- 3 garlic cloves
- 4–5 Tbsp grated parmesan
- salt to taste
- black pepper
- peperoncini powder

- Put the spaghetti in a pot of boiling, salted water and cook until "al dente."
- While spaghetti is cooking:
- Peel and cube the onion. Peel and crush the garlic using a garlic press.
- Wash and drain the prawns.
- Wash, dry and quarter the cherry tomatoes.
- Heat olive oil in a frying pan, add crushed garlic and prawns and sauté for about 3–4 minutes.
- Add cherry tomatoes and grated parmesan to the pan and sauté everything together for about 5 minutes.
- Season with salt, pepper and chili powder to taste. Put the strained spaghetti back in the pot, add the sauce and mix.

Wooooord, just eat it!

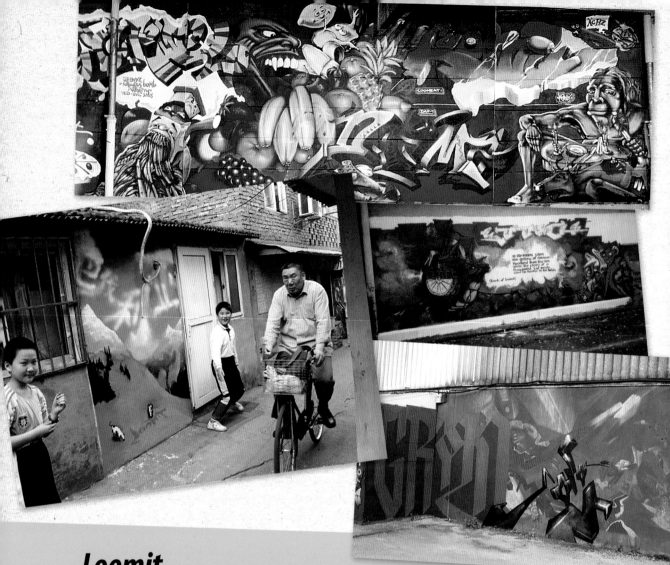

Loomit

In 1983 Loomit's first exposure to the New Yorker Hip Hop scene inspired his illegal painting of the Buchlo water tower using spray paint provided by his mother. Encouraged by the success of having a photo of his work appear in the local press, he started painting more. Moving to Munich, where there were larger numbers of active graffiti sprayers, broadened Loomit's horizons. He started using the name Loomit during his first court case in 1984. In the same year Loomit also began painting urban commuter trains. Then, in 1986, he began his travels to Dortmund, Amsterdam and Paris, where he made a lot of contacts and painted a great deal. In 1987, after his second major court case, he traveled to New York for the first time, where he met Henry Chalfant, the author of the book 'Subway Art,' and the graffiti legend Seen.

In 1992 he traveled to New Zealand, Australia, the US, Canada and England, painting four to five pieces a month with different local writers. In 1993 he was invited to paint the bathroom of the mayor of Munich, and was commissioned to paint the outside walls of the former Riem airport, which was used for flea markets and concerts.

Then, in 1995, Loomit started an apprenticeship to become a tattoo artist under Seen in the Bronx. He continued his tattoo training in the Munich tattoo studio Positive Vibration. In December of that year he took part in painting a high rise in Bergedorf-Lohkamp, which received a place in the 'Guiness Book of World Records' as the highest graffiti piece in the world. In 1996 he had his first solo exhibit in Darmstadt. The following year he moved into his studio in Kunstpark Ost, whose walls have been decorated by many international guests over the years.

Loomit has done commissioned works for many companies and other organizations, as well as for special events, such as a mural for the soccer World Cup in Nantes (1998). He has participated in numerous exhibitions and collaborations worldwide, such as the 'Mural Global' in Sao Paulo with Os Gemeos and the creation of five large-format murals (160 square meters) as part of the Greek Cultural Olympics. Loomit has won several awards for his work, including the Swabian Art Prize in 2002, and has also been a jury member at various painting competitions. Another highlight of his career was painting one of the first legal trains in Rio de Janeiro together with Os Gemeos, Pete and Nunca.

Köhler's Chantrelle Dumplings

Dumplings:

- 300g *(1¼ cups)* dumpling bread (substitute: cubed rolls)
- 170ml *(6fl oz)* milk
- 3 eggs
- 1 Tbsp parsley leaves
- 1 small onion
- 2 Tbsp butter
- a small amount of flour
- salt, pepper
- freshly grated nutmeg

- Put the dumpling bread or cubed rolls into a bowl. Warm (not boil) the milk in a pan or microwave and pour it over the bread. Add the eggs, sprinkle flour over the mixture and season.
- Sauté the finely chopped onion and parsley in butter and add this to the mixture.
- Mix the dough thoroughly and let sit for 10 minutes.
- Knead the dough again and add salt and pepper to taste.
- Form nicely shaped dumplings (this is easier when you wet your hands).
- Drop the dumplings into boiling, salted water. Don't cook too many dumplings at once; they should have plenty of room.
- Let the dumplings cook for 15–20 minutes in lightly boiling water.

Chantrelle sauce:

- 400g *(14 oz)* chantrelles
- 1½ Tbsp butter
- 120g *(½ cup)* cream
- 350ml *(1½ cups)* vegetable bouillon
- 1 small bay leaf
- 20g *(4 tsp)* dried, mixed mushrooms
- 1 strip of lemon peel
- salt, pepper
- caraway
- cayenne pepper

- Peel and cut the onion into cubes. Sauté the onion in a pot with oil until transparent.
- Add the vegetable bouillon, bay leaf and dried mushrooms to the pot and let it simmer for 20 minutes. Remove the bay leaf, add cream and puree with an immersion blender. Add the liquid (through a sieve) to a pot. Slowly stir in the butter.
- Wash the chantrelles and sauté them briefly. Add salt and pepper. Add the lemon peel and chantrelles to the cream sauce, let it simmer for a while. Remove the lemon peel and season the sauce with salt, pepper, cayenne pepper and caraway.

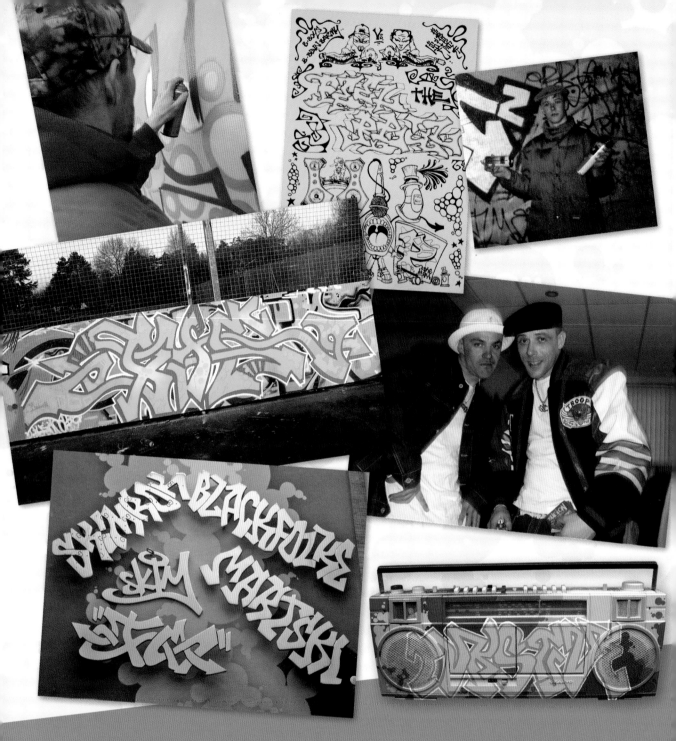

Pyestar

Dave Pyestar was born in 1973 in Worcester, England. He started drawing, dancing and listening to music from a very early age, so when Hip Hop culture hit his part of the UK in 1984 he started poppin', b-boying and writing graffiti. In 1990 he added emceeing to the list.

Together with his crews Sub Kon and KFO (graff) he continued to further his Hip Hop art forms when others gave up and moved on to the next trend. He has orga-

nized and hosted jams and workshops from the 90s to the present day, promoting all elements of Hip Hop culture and teaching children and teenagers from all walks of life.

Four years ago he set up his own business, Inkstink (inkstinkizmz), making hand cut graffiti name buckles and jewelry, which has successfully spread throughout the Hip Hop community worldwide. Now a father of two (Freddy and Edie), Pyestar still represents the UK Zulu Nation, KFO, Sub Kon, Battle Holex and MHR—forever!

Smoked Quick Chicken

- Preheat oven to 200° C *(390° F)*. Crush the cloves and finely chop the garlic, then mix together with the rest of the seasonings.
- Remove the skins from the chicken thighs and coat the thighs with the seasoning mixture.
- Place the thighs close together in a small oven pan and sprinkle any leftover seasoning over the top, cover with foil and cook for 40 minutes, removing the foil for the last 5 minutes of cooking.
- Drain and serve with green leaf salad, spring onions and rice.

Ingredients:

- **750g *(about 1½ lbs)* chicken thighs**
- **1 Tbsp smoked paprika**
- **¾ Tbsp mild chili powder (if you don't like it hot, use less!)**
- **1 Tbsp sugar**
- **½ tsp coarse ground black pepper**
- **½ tsp salt**
- **2 garlic cloves**
- **3 cloves**

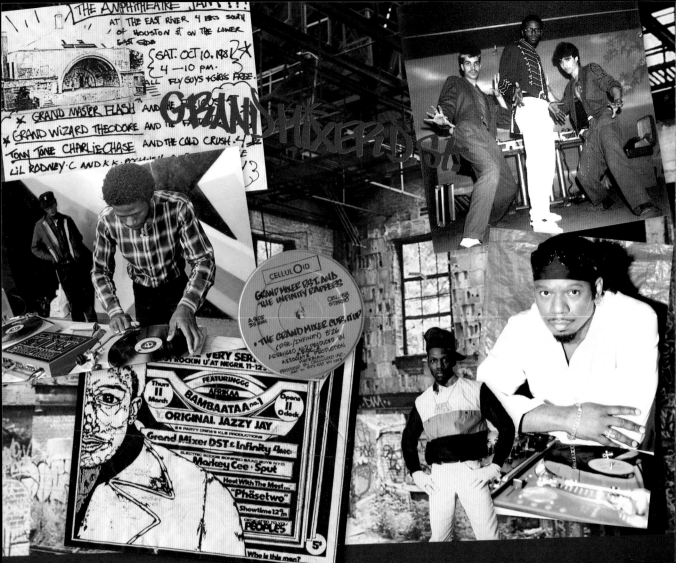

Grand Mixer DXT

Grand Mixer DXT, formerly Grand Mixer D.St., is recognized as the first turntablist to establish the turntable as an improvisational instrument. His original name, Grand Mixer D.St., references New York City's Delancey Street "D.St." in the Lower East Side. DXT began his music career as a drummer, but was influenced early on by the father of Hip Hop culture, the legendary Kool DJ Herc, when he started spinning records in the early 70s. Using what he had learned as a drummer, DXT used the turntable like an instrument to control both rhythm and pitch. His work as a DJ in the early 1980s New York Hip Hop scene included being a featured DJ at the Roxy, a legendary downtown Manhattan club that helped expose the burgeoning Bronx Hip Hop scene to the world.

In 1982 DXT was on the first ever Hip Hop tour of Europe with artists such as the Rock Steady Crew, Afrika Bambaataa, Futura 2000, Dondi, Fab 5 Freddy, Infinity 4 Emcees, Double Dutch Girls and Phase 2. The following year his turntable performance in the seminal hit 'Rockit' on Herbie Hancock's album, 'Future Shock,' was one of the first songs to use a turntablist as a member of the band.

This Grammy Award winning track is widely regarded as a leading factor which influenced the popularity of Hip Hop in the mainstream media. DXT toured with Hancock's Rockit and Headhunters groups, and performed on Hancock's 2001 release, 'Future to Future.'

In addition to his career as a DJ, DXT works as a recording engineer and producer, through which he has worked with artists such as Bootsy Collins, The Last Poets, Sly and Robbie, Manu Dibango, and Doug E. Fresh, among others. When the 1957 Thelonious Monk Quartet with John Coltrane at Carnegie Hall concert tapes were discovered by the Library of Congress, T.S. Monk chose DXT to restore the nearly 50 year old tapes for a release on Blue Note records in 2005. Using a process he created called 'forensic editing,' he was able to restore the tapes to modern day standards. The quality of DXT's work stunned jazz audiences and made him the go-to engineer for bringing older jazz recordings to the modern age.

The film world has also been graced by DXT's presence with his big scene at the end of Charlie Ahearn's movie 'Wild Style' and by having the main character in the film 'Beat Street' based on him. DXT is currently producing the score for 'Check the Rhyme,' a feature-length documentary on Hip Hop music. A pioneer in the Hip Hop scene, DXT is an original Hip Hop icon.

DXT BBQ Biscuits

This is a hearty recipe and great for winter months! It's quick, too.

Ingredients:

- 450g *(1 lb)* of ground turkey (or ground beef)
- favorite barbecue sauce (to taste)
- biscuits (see recipe on page 110)
- 1 small onion
- 1 green pepper (seeded)
- sea salt, pepper
- about 2 Tbsp olive oil

- Chop the onion and green pepper and sauté in olive oil. Add the meat and seasonings to the pan and brown until the meat is thoroughly cooked. Add the barbecue sauce and let it simmer for 5 minutes.
- Preheat the oven to 180° C *(350° F)*. Place biscuits in lightly sprayed (oiled) muffin tins. Scoop out the center of the biscuits. Place the meat inside the scooped out middle area of each biscuit. Place in oven for 15 to 20 minutes, until biscuits are golden brown. Serve with fresh, steamed vegetables.
- Optional: Top BBQ biscuits with cheese.

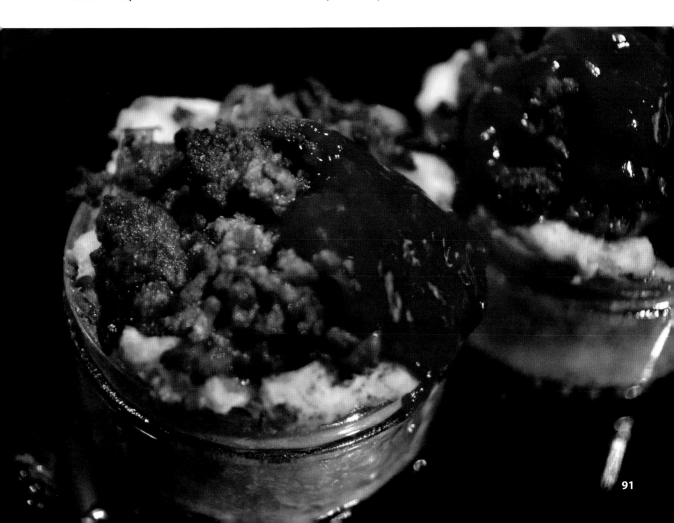

Zulu Gremlin

As a world renowned b-boy and MC, Zulu Gremlin has contributed greatly to Hip Hop culture since the early 80s. He is a former member of the first ever Hip Hop off-Broadway musical, 'Jam on the Groove,' and the world famous Rock Steady Crew. Zulu Gremlin was also a member of the rap group the Latin Alliance, which signed with Virgin Records. He was fortunate to take part in the first exhibit of Hip Hop at the Rock and Roll Hall of Fame, as well as 'Rhythm and Roots,' the celebration of American music and dance showcased in the National Museum of American History of the Smithsonian Institution. Presently, Zulu Gremlin is a member of Medea Sirkas, 7 Germs, the Break Beat Assassins, and the Hidden Masters Elite.

Zulu Gremlin's Yellow Chicken Curry

Ingredients:

- oil
- 115g *(4 oz)* yellow curry paste
- 400 ml *(14fl oz / one can)* coconut milk
- 1kg *(about 2 lb)* boneless chicken thighs
- 1 medium onion
- 3 medium potatoes
- 1 red bell pepper (seeded)
- 1 yellow or green bell pepper (seeded)
- salt and pepper for the chicken

- Slice the onion and chop the peppers into about 5 cm *(2 in)* chunks.
- Peel and cut the potato into chunks.
- Season chicken with salt and pepper to taste.
- Brown the chicken in skillet with a little bit of oil.
- Remove chicken, set it aside, and wipe the excess oil out of the skillet.
- Add the curry paste and coconut milk to the same pan.
- Let it simmer until it starts to bubble.
- Add the chicken, onions and potatoes to the curry mixture, and bring it to a boil. Make sure there is enough liquid to cover the chicken and potatoes, if not, add water.
- Once the potatoes are tender, add the bell peppers and cook for 10 more minutes.
- Serve over steamed jasmine rice.

Darco FBI

Darco was born in 1968, in Bielefeld, Germany. He moved to France in 1976, where he developed an early interest in art—specifically graffiti writing—and painted his first piece in a suburb of Paris in 1984. Since the early 1980s, Darco has received recognition for his style of writing, and is credited for influencing generations of graffiti writers across the globe.

Darco specializes in the art of lettering. Although he has retained the graphic side of the outline, his style is often labeled as 3D. Darco's work stands out through its original styles, perspectives and the dynamics of varying forms and colors.

In 1985, Darco and Gawki created the legendary writer crew FBI, which is now an international artist collective. The crew has acquired the respect of graffiti artists and followers across the world through its originality, choice of subject, concept, style, size, quality of work and extensive global travels.

Darco was the first graffiti artist in France to be convicted for damage to public property in 1989. As a result, the authorities wanted to make an example out of him and he received an extremely harsh punishment. After much deliberation and discussions with different ministries and in the media, the SNCF (French Railway) decided to set a new punishment for the crime. In the end, Darco was asked to paint several murals for the train company in order to work off the fine. A few years later, in 1994, Darco was invited to be involved in the renovation of Europe's first train station—Gare du Nord. The result was a mammoth spectacle—the creation of 900 square meters (~ 9700 ft²) of murals in one of the world's busiest stations.

Since 1992, Darco has held the title of one of Europe's first graffiti writers to acquire the official status of 'artist.' He is also a member of the American crew UA and the Australian crew TFC. Along with Darco's artistic research, he works in several areas of the artistic industry, including decoration, graphic design, fashion, set and stage design, and as an art director, adviser and consultant. He also regularly works in Europe, South Africa, the USA, Australia and Canada. In 2006, a book about his art, called 'Darco Code Art,' was published by Editions Alternatives / L'OEil d' Horus. Darco was the artistic adviser of Jean Jacques Beineix, as well as the body double of Olivier Martinez in the film 'IP5.' He also sketched a complete concept for DJ Vadim's album 'The Art of Listening.'

Hermès celebrated the beginning of 2012 by inviting Darco to use his graffiti talent to design the shop windows of its luxury store in the Dubai Mall. He was also one of the artists chosen to customize a bottle of Clarins' Eau Dynamisante for its 25th anniversary display at Colette (a fashion store) in Paris.

Darco's work has been exhibited in the museums Palais de Tokyo, Centre Georges Pompidou, Kaltmann Museum, Musée des Arts et Traditions Populaires and the Grand Palais in Paris, France. Today, Darco continues to work in a consistent and meticulous manner, remaining faithful to the essence of graffiti writing and all that he has worked towards.

Wild Style Salad

*I have always loved cooking, probably because I am a bit of an alche-
mist. I love watching my grandmother, mother and aunt cook, and I
also enjoy helping prepare dishes, when they allow me to. In fact, I was
the one who got to lick the pan and peel the vegetables and fruit! At
least until the day I cut a ham and my finger at the same time...*

Ingredients:

- wheat kernels (about 1 cup per person)
- 1 bay leaf
- 1–2 cloves of garlic
- 1 Golden Delicious apple
- 1 cooked beetroot
- 4 or 5 pickled cucumbers
- 2 Tbsp sunflower seeds
- 1 Tbsp sesame seeds (light brown or black)
- 1 Tbsp raisins (black or green)
- 1 Tbsp fried onions (you can find them in Asian super-
 markets or you can make them yourself)
- 1 shallot
- 1 pinch of herbs de Provence
- 1 pinch ground ginger (or freshly grated)
- 1 pinch ground turmeric (or freshly grated)
- 2 sprigs of parsley
- juice from 1 lemon
- 4 Tbsp of walnut oil
- 2 Tbsp of balsamic vinegar
- 1 dash of salt
- 1 dash of pepper

Cook the wheat in boiling, salted water, with a bay leaf
(optional), until soft but slightly "al dente" (for my taste).
While the wheat cools, prepare the remaining ingredients.
Crush the unpeeled garlic cloves with the flat side of a
knife, this will help you remove the skin. Peel the apple.
Slice the apple and cut the beetroot into small pieces.
Cut the pickles into strips and chop the parsley, garlic
and shallots. Once cooled, put the wheat in a bowl. Add
the seeds, raisins, spices, apple, beetroot, pickles, garlic,
parsley and shallots. Squeeze the lemon. Season the salad
with salt, pepper, walnut oil and balsamic vinegar. Pour
out any excess dressing, and wait 10 minutes so the wheat
can absorb the taste and serve.

Optional: You can obviously replace or add what you
feel like: cherry tomatoes, dried tomatoes, olives, endives,
fresh dates, broccoli… But if you use tofu, bacon, chicken,
gizzards, liver or shrimp, add them while hot, and at the
last moment. You can also try different spices or dried fruit,
and grate the ginger and the turmeric if they're fresh.

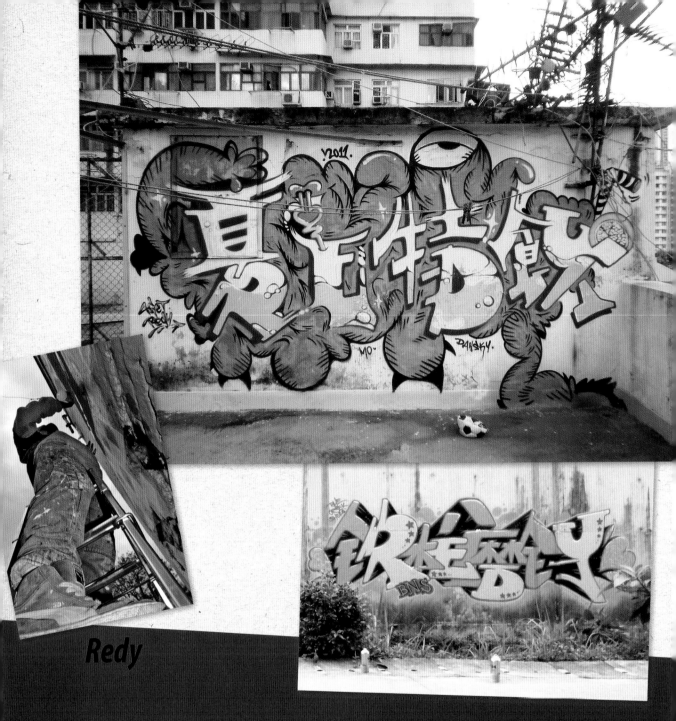

Redy

Redy, a female graffiti writer from Hong Kong, started doing graffiti in the new millennium. She has met many graffiti writers from around the globe over the last dozen years. Graffiti writers either visit her in Hong Kong, or she travels to different places to say hello to her friends. No matter where the writers come from or whatever interests they have, there is one thing they have in common: they must eat.

Once in a while, graffiti writers decide to cook for their guests (or hosts). Redy is lucky enough to have met up with Igit from Cologne, Stak and Honet from Paris, Hobsek from Montpellier and Hong Kong, Siriusmo and Gogoplata from Berlin, AndC from Beijing, and many others who were very kind to prepare a meal for Redy and her friends.

In the beginning, Redy was not into cooking and she could barely bake a cake. However, by traveling around and organizing projects and events, she has had more chances to prepare food for her boyfriend, friends, project partners and participants. She started cooking more and more often and now experiments more. In the end, she managed to offer her friends and fellow artists a proper meal. Redy would like to thank Gerry and Akim for inviting her to be part of the Hip Hop Cookbook. Hopefully the readers will enjoy and survive her recipe!

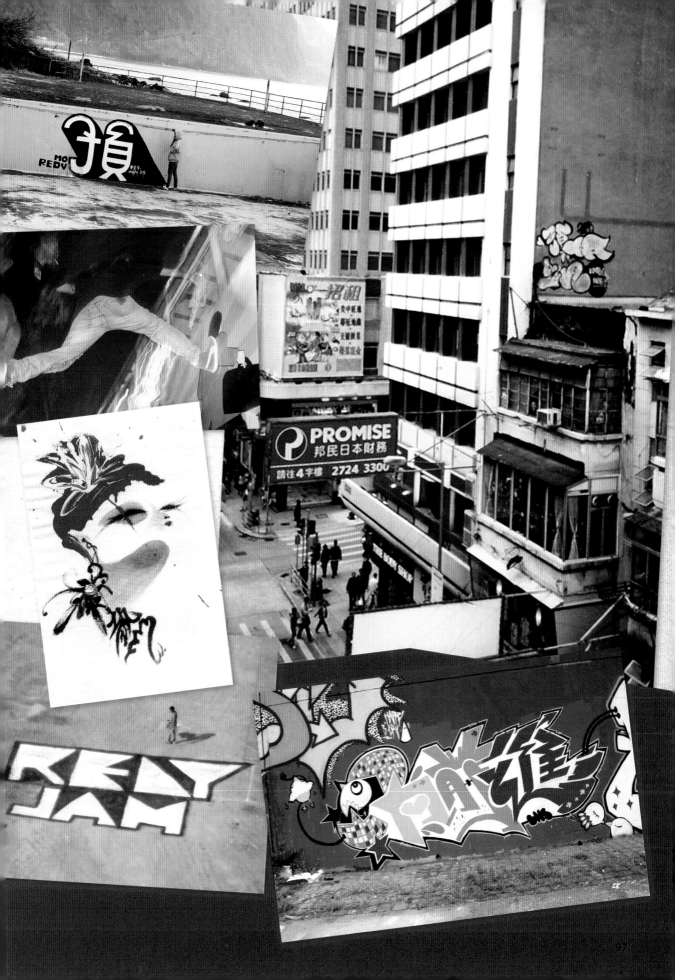

Daikon Radish Chrysanthemums

Prepared for Siriusmo

Chrysanthemums:

- 1 daikon radish
- ⅙ tsp salt
- oyster sauce

- Peel the radish and cut it into a cube approx. 2.5 cm x 2.5 cm x 15 cm *(1 in x 1 in x 6 in)*.
- Slice the radish cube into 1 mm *(0.04 in)* thick pieces, about 25 slices.
- Put the radish slices in a bowl (recommend stainless steel), cover with water and let rest for 10 minutes.
- Pour 750ml of hot water into pot, add salt and radish slices and cook just until the radish becomes soft and pliable. Drain and put into a bowl of cold water.

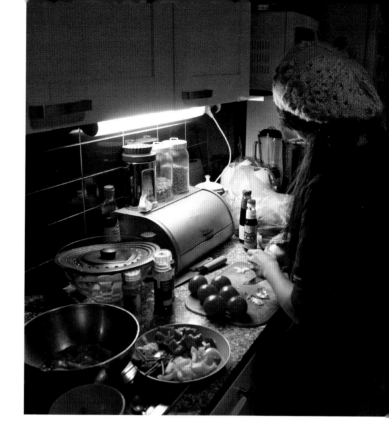

- After the radish has cooled, place one slice horizontally on a cutting board. Starting at 0.5 cm (¼ in) from the lower left corner, make small 0.5 cm (¼ in) vertical cuts every 0.5 cm (¼ in) until you're 0.5 cm (¼ in) away from the right corner of the radish slice. Repeat this process until all the radish slices have been cut.
- Horizontally place one of the slices, cut side up, on a plate. Use your fingers to pick up the lower and mid sections of the slice, fold over a small amount of the slice and roll it to the other end (You can use two or four slices if you want the chrysanthemums to be bigger). Use a toothpick or small skewer to keep the radish slice from unrolling.
- Arrange all the rolled radish chrysanthemums on a heat-resistant plate.
- Pour 200ml (1 cup) hot water into a wok and place the plate with the radish chrysanthemums on a steaming rack above the water. Cover and steam for 3 minutes.

Cucumber grass:

- Wash 1 cucumber, cut off the ends and cut it in half lengthwise. Cut the halved cucumber vertically into 2.5 cm (1 in) chunks.
- Leaving one edge intact, make 5 even, vertical cuts about 1 cm (¼ in) from the edge of a cucumber chunk.
- Holding the uncut edge of cucumber, fold and tuck inwards the 2nd and 4th slice of the cucumber chunk.
- Repeat the process until you have as many pieces of cucumber grass as you want to decorate the plate with your radish chrysanthemums. Decorate the plate and use the oyster sauce to create a pattern or draw a design.

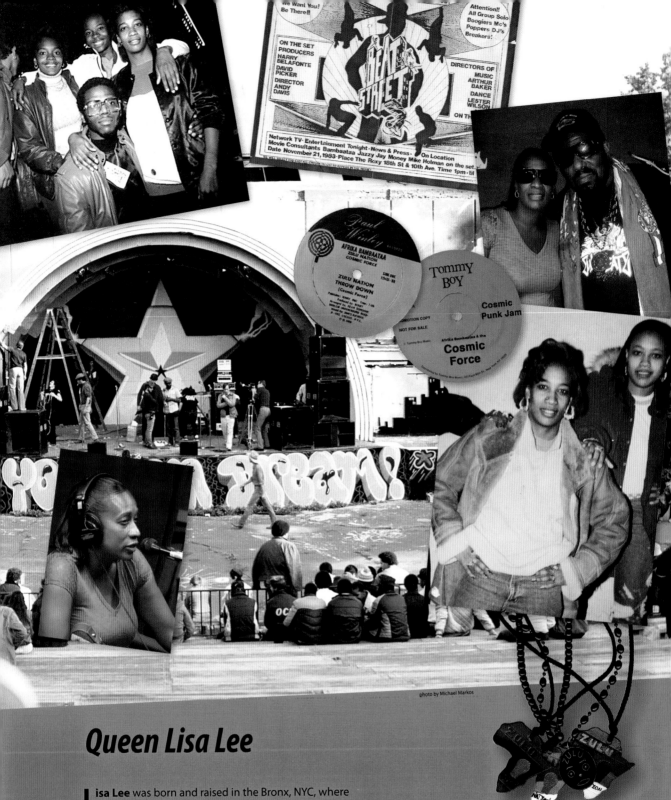

photo by Michael Markos

Queen Lisa Lee

Lisa Lee was born and raised in the Bronx, NYC, where she grew up listening to all kinds of music. Lee and her brothers got two turntables, a mixer and an echo chamber when she was ten years old. At the age of 13 she attended her first Hip Hop Jam, Afrika Bambaataa, and DJ Mario were there. She asked Bambaataa if she could rock the mic and the rest is history!

She became one of the original Zulu queens and represents the Zulu Nation today, just as she did back in the 70s. In 1979 Lisa Lee became a member of Bambaataa's group Cosmic Force. They recorded the 'Zulu Nation Throwdown,' which was one of the first Zulu Nation recordings, on Paul Winley Records. She is known worldwide for her part in 'Wild Style,' in which she freestyles together with Busy Bee during a limo ride. She was also a part of the female rap group Us Girls in 'Beat Street.' Lisa Lee is an original Hip Hop icon from the Bronx, NY.

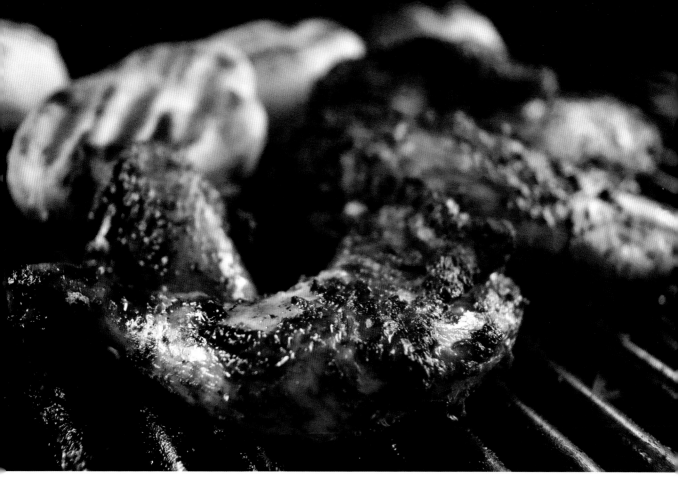

Jamaican Jerk Rub Chicken

My mom was born and raised in Jamaica, so I've always enjoyed preparing dishes from that area.

Ingredients:

- 6 whole chilis
- 1 tsp garlic powder
- ½ tsp cinnamon
- 1½ tsp black pepper
- 1¼ Tbsp salt
- ¾ tsp nutmeg

- 50g *(1.8 oz)* chives
- 1 pinch ground cloves
- ½ Tbsp vinegar
- ½ Tbsp brown rum
- 1 whole chicken (with or without bones)

- Remove the stems and seeds from the chilis and finely chop. Quarter the chicken and cut the chives into thin rings. Put all the ingredients except the chicken into a food processor or blender and puree. Completely cover the chicken with the pureed spice paste by rubbing it well into the meat. Allow the chicken to marinate for 2–3 hours before cooking.
- You can either cook the chicken in a pan with pure canola oil or grill it on the barbecue.
- Enjoy this spicy dish with white rice and plantains.
- The amount of chicken you use depends upon your hunger! You can halve the recipe or use only half the sauce and save the rest for another day.

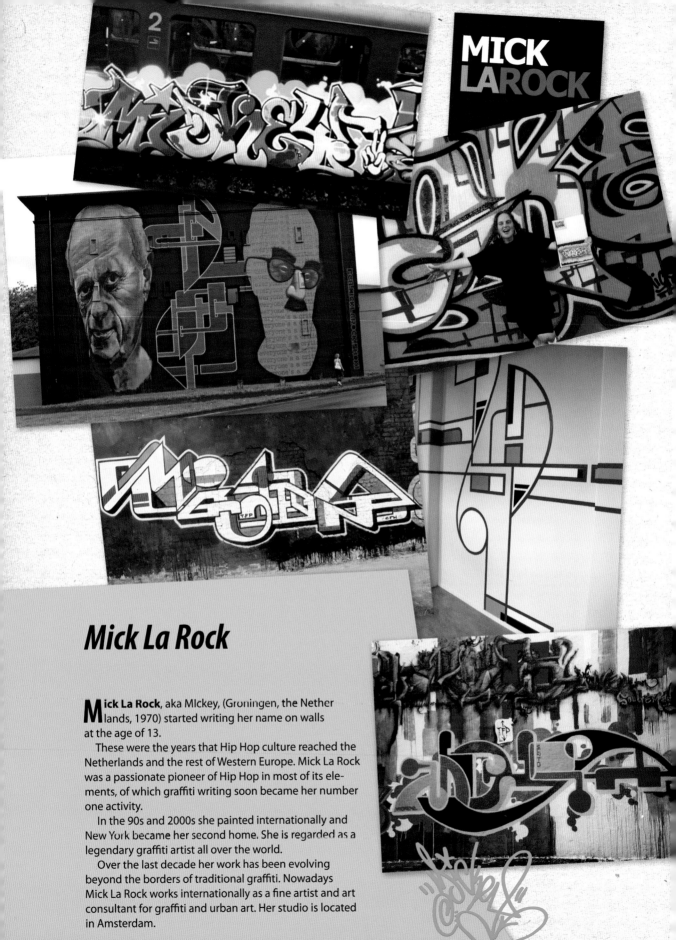

Mick La Rock

Mick La Rock, aka Mickey, (Groningen, the Nether
lands, 1970) started writing her name on walls
at the age of 13.

These were the years that Hip Hop culture reached the
Netherlands and the rest of Western Europe. Mick La Rock
was a passionate pioneer of Hip Hop in most of its ele-
ments, of which graffiti writing soon became her number
one activity.

In the 90s and 2000s she painted internationally and
New York became her second home. She is regarded as a
legendary graffiti artist all over the world.

Over the last decade her work has been evolving
beyond the borders of traditional graffiti. Nowadays
Mick La Rock works internationally as a fine artist and art
consultant for graffiti and urban art. Her studio is located
in Amsterdam.

I love to cook. My favorite cuisines are Surinam, Caribbean and South Italian, but I cook dishes from all over the world. The greatest thing for me is to cook with friends and guests and to learn their recipes. For many years I lived in Bijlmer in the southeast part of Amsterdam. This special area houses a very multicultural community and was one of the cradles of Hip Hop in Amsterdam back in the mid 80s. A friend from Ghana showed me once how to cook this soup. Did you know that peanuts are called groundnuts in Ghana? That's why this is called groundnut soup. I like to cook it when I'm expecting a lot of visitors: it serves up to 8 people and can be used as a main course.

Groundnut soup from Ghana

Ingredients:

- 1 whole chicken
- 1 chunk of beef
- 1 chopped onion
- water
- 400g *(14 oz)* canned tomatoes
- 6–10 Tbsp West African peanut paste (or same amount of unsweetened peanut butter)
- ½ fresh red hot pepper (or any amount of hot pepper to taste)
- 6 sweet pepper (allspice) grains
- 1 Maggi cube (or other bouillon cube)

- Cut the chicken into bite-sized pieces. Do the same with a nice big chunk of beef (the part that tenders when simmered).
- Chop the onion into small pieces. Put all of the pieces of meat, chopped onion and salt in a large soup pot or Dutch oven and simmer on medium heat in its own juices. If there is not enough liquid in the bottom of the pot, add 50 ml *(¼ cup)* water. Stir well once in a while. In the meantime, puree the canned tomatoes with the hot pepper with a blender or food processor.
- Wait until the meat is completely browned, then add the tomato mixture and approx. ½ liter *(about 20fl oz)* boiling water and stir. Add peanut paste. The amount you need depends on the amount of meat you use. No additional oil is needed—the peanut paste contains enough. Add more water, ½–¾ liter *(20–25fl oz)*, the allspice grains and a Maggi or bouillon cube. Now bring it to a boil on high heat and let it boil for 5 minutes. Then lower the flame to medium and let the soup simmer until it reaches the right thickness. The allspice grains cannot be eaten. Serve with boiled white rice and fried sweet plantain.

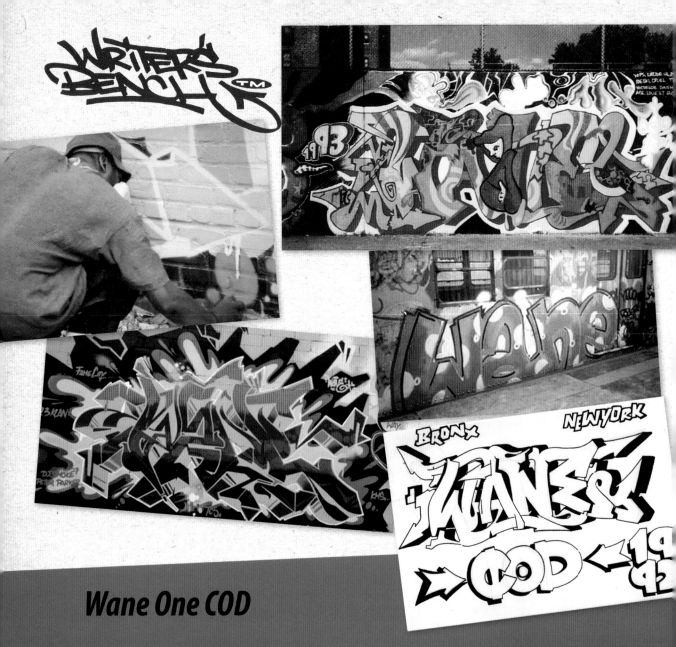

Wane One COD

Born in 1970 in the United Kingdom, Wane is of West Indies descent and grew up in England. In 1978, Wane's parents brought their two sons to the US and moved to the north Bronx. They lived in a fifth floor apartment, which faced the 2 and 5 subway lines. He slowly became obsessed with watching and admiring the many great subway graffiti writers of the late 70s and early 80s.

In 1984 he became Wane One when he painted his first train with the very same writers he admired and finally made the grade as a writer himself. This was the beginning of a lifelong love for graffiti and the culture that surrounds it. From '84 to '88 Wane spent his days and nights perfecting the art of painting subways, and became well known throughout the five boroughs for his writing under several aliases. Other writers recognized his original style and soon he established a bond with many serious subway painters. Soon enough, Michelob, the founder of the renowned crew COD (at the time Children of Destruction) passed the crew over to Wane, and from then on

Wane became a truly central figure in New York's scene and started painting with numerous other writers such as Wen, Dero, Wips, Reas, Ghost, Ket, Dash, Skeen and Ven One from Brooklyn. Wane started experimenting with and exploring other medias, such as acrylic on canvas and denim jackets and pants. He also began airbrushing T-shirts, which became popular in the neighborhood, and gave Wane his first taste of being an entrepreneur.

Wane started the T-shirt clothing brand Writers Bench, inspired by the history of graffiti and the original Writers Bench at 149th street, where writers used to congregate. Designing T-shirts, caps and stickers, he immediately sold his products in the US, Europe and Japan. Writers Bench quickly became a household name within the street-style fashion world. For several years Wane built up the brand and developed his computer graphic skills.

Presently, Wane divides his time between painting, Writers Bench, menswear design and traveling around the world. Wane still resides in the Bronx.

Caribbean Drink

I was born in the UK, where my parents met (one is from Grenada and the other is from Barbados). I lived in Grenada with my older brother and grandmother for four years before I moved to New York City and started painting in subways. This was was my favorite drink growing up as a child in Grenada, and it's still the only thing I will cook.

Hope you enjoy it. Peace & Blessings!

Ingredients:

- 0.5kg *(1 lb)* sugar
- 3.8 L *(1 gal)* water
- 113g *(¼ lb)* ginger root (chopped or crushed)
- 113g *(4 oz)* sorrel

- Put all of the ingredients in a container large enough to hold 7.5 liters *(2 gal)* of water. In a large pot, boil the water for about 30 minutes, and then pour the water into the container with all the ingredients.
- Cover tightly and steep over night. I recommend letting the water steep for 12 hours.
- Strain the liquid into another large container, and discard the remaining sorrel.
- Let the solution cool to room temperature, and then sweeten to taste with sugar.
- Serve this drink in a glass with ice.
- You may add a little rum, red wine or even lemonade to enhance the flavor (about a shot glass full).

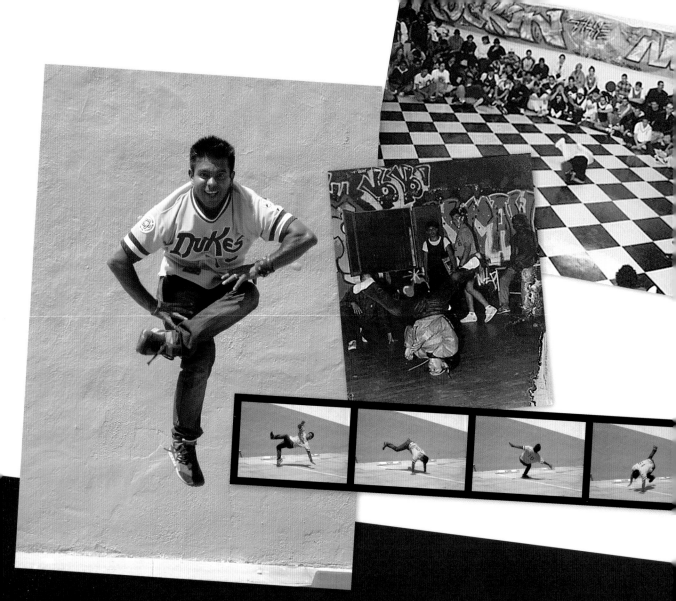

Lil' Cesar

At 5'1", **Julio "Lil' Cesar" Rivas** stands tall as an original b-boy dance pioneer and one of the most influential West Coast names in Hip Hop. Lil' Cesar advanced from his Central American birthplace, El Salvador, to the inner-city streets of Los Angeles, to performing on stages all over the world, including Buckingham Palace in 2002. Lil' Cesar started his dance career in 1982 at the corner of 7th and Union. He has traveled to over 27 countries and shared the stage with many world-class performing artists. He has appeared numerous TV shows, documentaries, books, newspapers, magazines and commercials. In addition to his collaborations with many acclaimed artists in music videos, he's done live performances with Madonna, Kurtis Blow, Ice T, Exhibit, Melle Mel, Lenny Kravitz, Soul Train and Britney Spears.

Lil' Cesar has received several awards throughout his career for his accomplishments in Hip Hop and contributions to promoting human rights. He is the leader and one the founders of the internationally recognized b-boy Air Force Crew, which is known for mastering and innovating some of the most amazing aerodynamic dance moves in Hip Hop.

Through his travels, Lil' Cesar began to recognize that Hip Hop is a global cultural movement. With the loss of many of his friends to drugs and violence, Lil' Cesar also realized that Hip Hop is a vehicle which can make a huge difference in the lives of young people. Lil' Cesar says, "instead of being on the streets drinking, smoking, fighting and ending up in jail or dead, I was dancing. Dancing kept me focused, it gave me a purpose to develop self-esteem and the character needed to reach my dreams." Hip Hop and the Youth Break Center Radiotron brought Lil' Cesar off the streets and gave him a space to train, be accepted and respected.

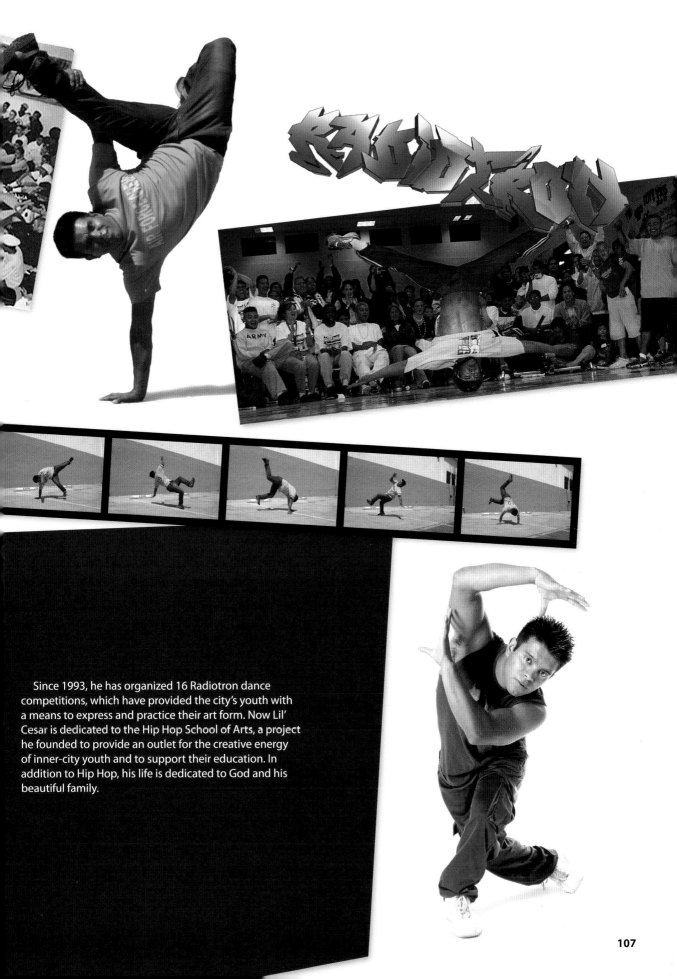

Since 1993, he has organized 16 Radiotron dance competitions, which have provided the city's youth with a means to express and practice their art form. Now Lil' Cesar is dedicated to the Hip Hop School of Arts, a project he founded to provide an outlet for the creative energy of inner-city youth and to support their education. In addition to Hip Hop, his life is dedicated to God and his beautiful family.

How To Make A Turkey – Salvadorian Style

Cleaning and marinating the turkey:

- 7 kg *(15 lbs)* turkey
- 3 lemons
- 60g *(½ cup)* salt
- 60ml *(¼ cup)* red or white wine
- juice from 1 fresh orange
- 60ml *(¼ cup)* of chicken bouillon
- 1 tablespoon of mustard
- 3 tablespoons of Perry (BBQ) sauce

- Defrost the turkey if frozen. Place the turkey on a rack roaster or in the sink for cleaning. Cut the lemons in half. Rub the turkey with the salt and lemon halves. Rinse the inside of the turkey well.
- Place the turkey on the rack roaster. Poke holes in the turkey with a regular knife, sprinkle it with wine, orange juice, bouillon, mustard and Perry sauce. Cover the turkey with another rack roaster and place it in the refrigerator for cooking the next day. Maria Teresa Cortez, Lil' Cesar's mom, recommends to let the turkey marinate for 7 to 10 hours.

Preparing the sauce:

- ¼ Tbsp thyme
- 115g *(4 oz)* natural sesame seeds
- ¼ Tbsp annato
- black pepper (7 whole peppercorns)
- 60g *(2 oz)* pumpkin seeds
- ¼ Tbsp whole cumin
- 2 bay leaves
- 1½ pasilla-ancho chili pods
- 1½ guajillo chili pods
- ¼ whole nutmeg
- 100g *(3.5 oz)* dark chocolate
- ½ cinnamon stick
- 2 cloves garlic
- ½ onion
- 230g *(8 oz)* olives
- 60g *(2 oz)* capers
- 1½ Tbsp Perry (BBQ) sauce
- 1½ Tbsp mustard
- 4 Tbsp chicken bouillon
- juice from 1 orange
- seasoning salt

- Place the ingredients (except the seasoning salt) in a cast iron griddle, cook on medium and stir until everything is toasted or grilled.
- Place 350ml *(1½ cups)* of water in a blender, add all the ingredients except the bay leaves and blend it for 30 seconds or until the sauce is completely smooth. Pour into a big bowl and add another 600ml *(2½ cups)* of water and ¾ Tbsp of seasoning salt. If the sauce is too thick, add water as needed.

Making the stuffing:

- **2 turkey legs**
- **1 bunch parsley**
- **1½ carrots**
- **1 potato**
- **1 tomato**
- **1 squash**
- **1 onion**
- **½ green pepper**
- **3 cloves garlic**
- **½ Tbsp olive oil**
- **140g** *(5 oz)* **green olives**
- **30g** *(1 oz)* **capers**
- **1 Tbsp Perry (BBQ) sauce**
- **1 Tbsp mustard**
- **½ Tbsp seasoning salt**
- **½ Tbsp table salt (regular)**
- **½ Tbsp of chicken bouillon**

- Bring 2L *(2 quarts)* of water to a boil. Add 2 turkey legs, a clove of garlic and ½ of the onion. Let it boil for 15–20 minutes, or until the meat is tender. Let it cool.
- Chop the potato, squash, parsley, carrots and tomato into small cubes. Place them all in a large bowl and add the regular salt.
- Strip the meat from the turkey legs and chop it into small pieces.
- Pour 118ml *(½ cup)* of water and the oil into a medium-sized frying pan. Cook the vegetables until semi-tender (about 5 minutes).
- In a separate frying pan sauté the vegetables with remaining garlic, turkey meat, green olives, capers, Perry sauce, mustard, seasoning salt and chicken bouillon. Cook for 5 minutes, stirring occasionally.
- Once everything is fried and tender, it is time to stuff the turkey.

Cooking the turkey in the oven:

- **bay leaves**
- **140g** *(5 oz)* **capers**
- **green olives**

- Place the turkey with the breast side down in a rack roaster.
- Stuff the turkey, then close the hole using pointed needles or skewers and tie it closed with string to hold the stuffing in place.
- Pour the sauce over the turkey until the rack roaster is ¾ full. Add the capers, olives and bay leaves to taste.

- Cook the turkey for about 3½ to 4 hours in a preheated oven at 200° C *(400° F)*. After 1 hour carefully open the oven, pull out the rack and use a ladle to pour sauce all over the turkey. Repeat this process 10 times while cooking (about every 15 minutes), so that the meat of the turkey is tender and flavorful. After 3½ to 4 hours, carefully flip the turkey over (it will be very hot!) and leave it in the oven for about 2 hours, pouring the sauce over the turkey every hour until turkey is fully brown and ready to eat.
- Take the turkey out of the oven and place it with the sauce on a rack roaster of your choice. Lil' Cesar's mom recommends serving the turkey on a plate with sauce, white rice, French bread and a salad of your choice. A typical Salvadorian way is to serve the turkey inside French bread with sauce, watercress, tomato, cucumber, radish and lettuce. This is called "pan con chumpe!"

Additional Recipes

Adobo

- 1 head of garlic
- 240ml *(1 cup)* vinegar
- 120 *(½ cup)* water
- 240ml *(1 cup)* soy sauce
- ½ Tbsp salt
- ½ tsp black pepper
- 3 bay leaves

Mince the garlic and sauté over low heat. Add the water, soy sauce, vinegar and sprinkle salt and pepper to taste. Stir and add the bay leaves. Cook on low heat for about an hour and remove the bay leaves before use.

Optinal: Top it off with garlic flakes (minced or thinly sliced garlic fried until golden brown) for added aroma.

Biscuits
(makes 12 biscuits)

- 250g *(2 cups)* flour (sifted)
- 2 tsp baking powder
- 4 Tbsp butter or shortening
- ½ tsp salt
- approx. 180ml *(¾ cup)* milk

- Sift the flour, measuring out 250g *(2 cups)*, add the baking powder and salt and sift again.
- Cut in shortening or butter (this is where I use my hands by rubbing the butter into the flour).
- Gradually add the milk, stirring until a soft dough is formed.
- Turn out on a slightly floured board and lightly 'knead' for 30 seconds, just enough for it to take shape.
- Roll out the dough until it's about 1 cm *(½ in)* thick and cut it with a 5 cm *(2 in)* floured biscuit cutter. Bake on an ungreased sheet in a preheated oven at 200° C *(400° F)* for 12–15 minutes.
- You can also make tiny tea biscuits that are only 4 cm *(1½ in)* wide with a small cutter or glass bottom. These are great served with tea, jam, or honey. Makes 24.

Puerto Rican Style Red Beans

- sofrito (Spanish seasoning)
- 2 cans red (kidney) beans
- 1 packet of sazón (1¼ tsp homemade sazón, see recipe on the right)
- 120ml *(½ cup)* tomato sauce
- 1 large potato
- 2 bay leaves
- vegetable oil

Cut the potato into small cubes. Then, heat a small spoonful of vegetable oil in a pot until it bubbles and drop a spoonful of sofrito into the hot oil and allow it to fry for 1 minute. Add the red beans, sazón, tomato sauce, potatoes and bay leaves to the pot. Stir, cover and cook for about 20 to 25 minutes on low heat. When the sauce thickens and the potatoes are soft, it's ready to be served.

Recaito

- 2 medium green bell or cubanelle peppers, seeds removed
- 2 medium onions, peeled
- 1 head of garlic, peeled
- 1 bunch cilantro leaves
- 6 ajiesdules (small, sweet chili peppers)

Chop and blend all ingredients in a food processor or blender.

Sazón
(best if made a few days before use)

- 1 bunch of cilantro *(about 2–3 cups)*
- 1 red bell pepper
- 1 green bell pepper
- 1 yellow bell pepper
- 3 Tbsp dry oregano (preferably Dominican oregano)
- 1 package of chicken bouillon
- 1 head of garlic
- 2 Tbsp *(30ml)* white vinegar
- 60ml *(¼ cup)* of water

- Wash the cilantro and peppers well. Chop the cilantro and peel the garlic.
- Seed the peppers and cut them into chunks.
- Put all the ingredients in a food processor or blender and add the chicken bouillon and the oregano. Many people like to 'grind' the oregano by using their hands. To do this rub the oregano between your palms to release the aroma. Dominican oregano has a very earthy and distinctive flavor.
- Add the vinegar and half of the water to the blender and puree. Add as much water as necessary to make sure everything is liquefied.
- Pour into a clean glass container with a lid and store in the fridge. Wait for a few days before using it to make sure the flavors are well combined, but if necessary, it can be used right away.

Secret Seasoning
Use a package of Italian salad dressing seasonings from the store (like Crazy Legs usually does) to make it quick or make your own version:

- 1 tsp carrot, grated and finely chopped
- 1 tsp red bell pepper, finely minced
- ¾ tsp lemon pepper
- ⅛ tsp dried parsley flakes
- 1 tsp salt
- ¼ tsp garlic powder
- ⅛ tsp onion powder
- 2 tsp sugar
- ⅛ tsp black pepper
- 2 tsp dry pectin
- a pinch of ground oregano

- Place the carrots and bell pepper on a baking pan in an oven at 120° C *(250° F)* for 45–60 minutes, or until all of the small pieces are completely dry, but not browned.
- Combine the dried carrot and bell pepper with the other ingredients in a small bowl. Mix can be stored in a sealed container indefinitely until needed.

Yellow Rice Puerto Rican Style

- 3 cups of rice
- 1½ tsp salt
- 1 Tbsp vegetable oil
- 60ml *(¼ cup)* tomato sauce
- 1 packet sazón seasoning salt with cilantro (1¼ tsp homemade sazón, see recipe on the left page)

Boil a little over 3 cups of water in a cast iron pot (or suitable pot for rice). Add the salt, vegetable oil, tomato sauce and sazón. Bring the water to a boil again and add the rice. The water should just barely cover the rice to prevent clumping. Boil the rice in the uncovered pot until the water level is very low, but do not let the water totally evaporate or the rice will burn. Then, reduce the heat to its lowest setting and stir the rice by turning it over in the pot. Cover and cook for another 15 to 20 minutes, or until rice is soft.